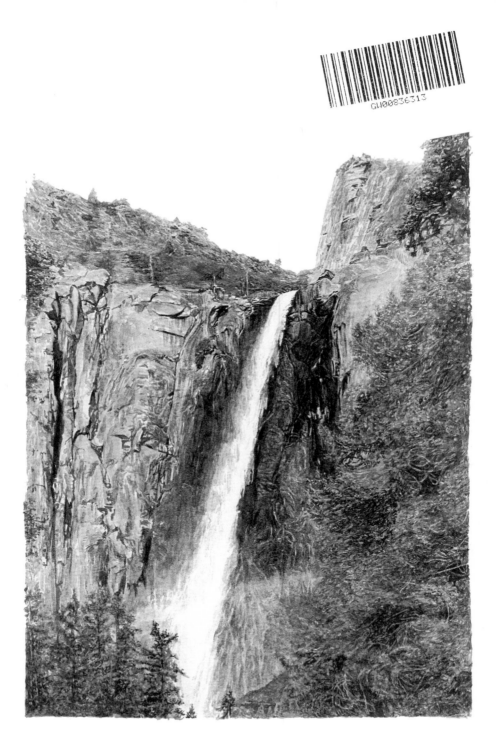

THE TROUT STREAM

A STICK OF GREEN CANDY

NARCISSUS BAY

CAMP CATARACT

IMAGES
by
COLTER JACOBSEN
STORIES
by
JANE BOWLES
and
DENTON WELCH

FOUR CORNERS
BOOKS
2009

Contents

THE TROUT STREAM

How well I remember
that first visit to Mr Mellon!
My mother and I had been asked to
spend the weekend at his great villa near
Tunbridge Wells. He was an old friend of my
father's, and since my father was abroad at this
time, I think he imagined that we were lonely, sitting in our
Kensington hotel, looking out at the fossilised trees in the
gardens of the Natural History Museum.

We set out on a dark rather foggy afternoon in early
autumn. The light under the dirty glass dome of the station was
thick and yellow. The train was just about to start and we had to
run down the platform to reach a coach. As I skipped along by
my mother, I suspected nothing. I was excited by the hurry,
rather pleased that we had to scramble in this way; but when the
door of the first coach had been wrenched open and my
mother's suitcase tossed on to the rack, I saw that there was
something strange about her. She stood, swaying a little, a sort
of smile on her face, her bag still open, although the porter had
been tipped. I thought that she was about to move her hands
and head in rhythm, perhaps even to hum a song. Then the
middle-aged man opposite had jumped to his feet, had taken
hold of her, was touching *my* mother! Between the little white
tufts of hair above each ear, his chunky lips were working up and
down in agitation. He was saying: 'Oh, is there anything I can
do, madam? Lean on me. Shall I get a doctor?'

He seemed impossibly fussy and protective. He was turning my mother into one of those fainting, delicate women I had heard about in stories, when really she was the strongest, most capable mother anyone could want. Why! running was nothing to her; she could dance and swim and ride and play all sorts of games. No one in the carriage would know this now, because of the man. They would all think her a weak woman who had to be held up, fanned with newspapers and given smelling-salts.

I looked up in amazement and said: 'What is happening, Mummy?' Then I pulled at her to make her sit down, for she was still standing, with her head almost against the man's shoulder. Slowly the train began to move out of the station. My glance darted up to the vast glass roof, so far away and threatening; it returned to my mother fearfully. But she was recovering. Her smile lost its sleepwalking quality before my eyes. She looked up at the man and thanked him charmingly for his attention, explaining that she had only felt faint for a moment; then she sat down beside me and took my arm.

We said nothing at first, each, I suppose, feeling relieved and yet shy. I was impatient with her, too, for giving the wrong impression to the people in the carriage; I had always been proud of her youthfulness and vigour. I was not to know that this was one of the first signs of the illness that was to separate us soon.

When we were near the end of our journey, my mother told me not to say anything to Mr Mellon or his housekeeper about her faintness, since she wanted no sort of to-do now that she was well again. So it was in a rather strained and careful mood that I left the train and went towards the long black car that was waiting for us. Already we were coming within the influence of Mr Mellon and I must let no word slip. The car itself with its high old-fashioned body and glittering carriage lamps, already lighted, was a disappointment. I had expected a man of Mr Mellon's wealth to have a Rolls-Royce, and here was something that I could not even give a name to. Still it was good to have

darkness outside, but to be in the warm padded box with my mother, to be smelling the slightly aromatic dried-up air and playing with the scent bottles, matchboxes and engagement tablets of old cracked ivory – the cracks were black, like my nails when I was sent to scrub them.

On the outskirts of the town we left the wide avenue and turned in between large clumsy gates. The car lamps glistened on the fresh paint, showing the branches of monkey-puzzles and rhododendrons beyond. There was a little lodge of grey and red rubbed brick. Everything was hard and ugly and beautifully kept. It reminded me of public parks or cemeteries; and this effect, together with the shock of my mother's passing illness, and her wish that nothing should be mentioned, all helped to oppress me, so that I dreaded coming to the end of the long curling drive, where Mr Mellon and his housekeeper would be waiting for us.

I suppose it was this wish to shut the world away from me that has made me forget almost all the details of our arrival. Just the sight of three huge plate-glass windows, curtained and lighted from within, remains. We were approaching them quickly; then there was the crunch as the wheels braked on the gravel under the granite porch.

It is the next morning that is still so clear. It must have been the hour before lunch. I know that my mother took me into the room where Mr Mellon always sat, the one with the three long windows.

It overlooked the gravel, the starfish flower beds and the whole stretch of lawn in front of the house. The sun was pouring in, draining the fire of colour, making the invisible flames seem rather overpowering. I had been told that Mr Mellon was an invalid, so his wheelchair did not surprise me. Only the plaid rug across his knees made me wonder fearfully what the legs could be like underneath. Were they all withered away? Were

13

they like drumsticks when the chicken has been eaten? The face beamed at me. I thought it looked like a very large, scrubbed, kind potato. There were only little mounds and valleys, all colourless and smooth with no wrinkles. Mr Mellon held out his hand and I went up to his chair. He held me against his side. He seemed extraordinarily fond of children, I thought; too fond to be quite comfortable, for I was conscious of his big body so close, the hardness of the wheelchair and the heat of the fire. Then the door opened and Mrs Slade the housekeeper came in.

Mrs Slade was the smiling, confident hostess, and yet somehow it was clear that she was no unpaid wife, friend, or relation; perhaps her very competence set her apart. My mother had explained to me that she was half-Javanese, but I could not quite accept her appearance and kept gazing at her whenever I thought that it would not be rude. I did not like her very soft, creamy skin, or the almost freckled duskiness round her long eyes, but their strangeness held me. I thought the grey seemed out of place in her black hair, for her body was flat and supple, like a young person's, and she was very small.

She began to ask my mother how she had slept, whether she had been brought exactly what she liked for breakfast; then she went over to the fire and wheeled Mr Mellon back a little, as if she knew, better than he did himself, what was comfortable for him.

'It's nearly time for drinks,' she said brightly, and turning to me so that I too should be included in her attention she added, 'My daughter Phyllis will be down in a moment; she is just washing her hands. It is so nice for her to have someone of her own age to play with.'

I was a little alarmed by Mrs Slade's efficiency, afraid of that smiling hardness. She seemed not to be aware of my nature or my mother's. Her mind was always occupied with the arrangements of the day; and the comforts and pleasures she planned for us were made to sound like duties. She was like the harsh little lodge, the monkey-puzzles and the sharp-edged drive.

The drinks were brought in by one of the tall Indian servants in his red turban and long white coat. As soon as he had left, Mrs Slade turned to my mother and said: 'The Indians are new since you were here last, aren't they?'

'Yes, where did you get them?' asked my mother.

They were indeed remarkable; all tall and silent in their red and white uniform. Ever since we had arrived I had been wanting to know why they were in this English villa. I knew that Mr Mellon had made his fortune in the East, but it had been the Far East, not India.

Mrs Slade was explaining.

'We had so much trouble with English servants that at last we thought we would try these Indians; they work as a team. A friend of Mr Mellon's told us of them.'

'They seem very good,' my mother said.

'Yes, I think they do their work well on the whole, and the cook makes excellent curries. You will see; we are to have one today.'

This was delightful news to me, since curry was almost my favourite dish.

At this time Mr Mellon had been beaming at me, at my mother and at Mrs Slade, sometimes saying a word, but usually leaving the conversation to Mrs Slade. Now he took from his pocket a little gold box and I was suddenly excited to see the lid blaze with large initials in diamonds. The initials were too big for the box, making it seem crusted and clumsy. I was still more excited when he opened the box and took snuff. Noticing my fascination he held out the box to me. I went up to him again and took it, but did not dare to smell the snuff, imagining that I would sneeze or choke at once. I just held the box and drank in its great value and the beauty of the diamonds.

'I thought only old people, people in history, took snuff,' I said uncertainly, thinking of wigs and swords and other things my mother had told me of.

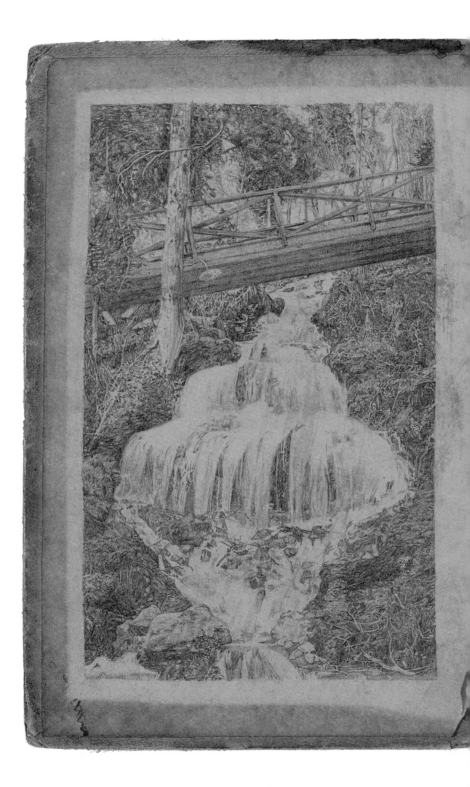

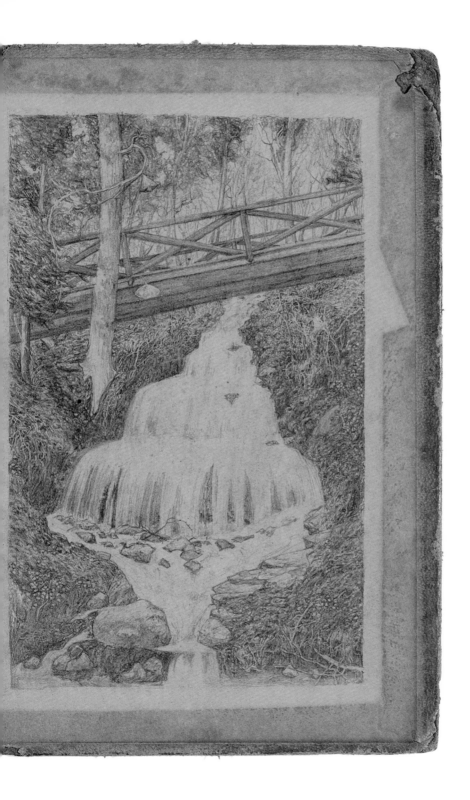

'I take it because I mustn't smoke, you see,' Mr Mellon said, then added: 'You like my box?'

For one intoxicating moment I thought he was going to give it to me. What would it feel like to possess a diamond-studded snuff-box? But he was only amused by my reverent interest. I felt he was almost laughing at me.

'I've another one here,' he said. 'I wonder if you'll like it better.'

He fished in his other pocket and brought out a box with a little urn of flowers on it. The urn, the flowers and ribbons were in every colour of precious stone. I tried to name them: ruby, sapphire, emerald, pearl – I knew no more.

'Oh, yes!' I said with a sigh of wonder and amazement. Could I be really holding such boxes? What would happen to them when Mr Mellon died? They seemed more desirable to me than anything else I had known.

Suddenly Mr Mellon took the boxes back from me, slipped them carelessly in his pockets and said with complete irrelevance: 'One day when my legs are better, you and I will go out in the woods behind the house and climb up to where the white elephant lives. I'd like to show him to you.'

I was nonplussed. I knew that Mr Mellon was paralysed and could never walk again. I knew that there were no white elephants – certainly not in England. Was this a game of make-believe? I was painfully embarrassed.

Mr Mellon saw it and laughed. I turned to my mother for help and guidance.

'Ah! Here is Phyllis at last,' broke in Mrs Slade. 'How long you've been!'

I guessed that Phyllis had been keeping away on purpose, for she was a dark heavy girl with nothing at all to say. Her eyebrows met in the middle and already she had black hairs on her arms. She stood against the wall, utterly impassive and confident. I could not help thinking her very ugly, and it was a shock to my self-satisfaction when Mr Mellon showed even more delight in

her arrival than he had shown in mine. He asked her to bring him one of the little cocktail tit-bits, then when she stood by him, he put his arms round her shoulders and said: 'Phyllis is a good old sort, isn't she! I've been talking about our white elephant, saying we must visit him when I'm up and about again.'

Phyllis's response to this was a sort of grunt that seemed both sullen and lazily good-natured. It was as if she knew his nonsense of old, but was ready to put up with more of it, since he was good to her.

At lunch I was surprised to see so many Indians; there seemed to be one for each of us, and they came and went with such silent smoothness. Sometimes there was the lowest murmur behind a screen, sometimes Mrs Slade made a sign with her hand; and her eyes followed them constantly. I felt the strain of her watchfulness and saw that she ate in quick abstracted snatches, hardly looking at her plate.

But the curry was what really occupied my attention. There was rice bright gold with saffron, chicken in its glistening brown sauce; then came innumerable little dishes of condiments. I suppose we had chutneys, Bombay duck, chopped coconut, egg, parsley, peanuts and many other stranger things I still cannot name. I know that I piled them up until I had a little mound, then dug into it joyfully with my spoon.

As soon as I had satisfied my greediness a little, I began to look about the room; at the walls covered with a heavily embossed gilt paper in imitation of Spanish leather, at the sticky landscapes and still-lifes in plaster frames almost a foot deep. Out of the windows I could only see lawns, laurel hedges and the corner of a white conservatory all cast-iron spikes, silvered poppy-heads and Gothic tracery. A sense of the deadness of things began to oppress me. I thought that all Mr Mellon's possessions looked as if no one had ever wanted to use them or enjoy them. I wondered why he had them and kept them in such perfect condition.

Mr Mellon's long head now seemed to me to be like a peeled satiny log. Phyllis next to him was like some coarse little fair negress, unaware of anything but food. Her mother's much more delicate Eurasian face with its smile and its strain filled me with uneasiness. I looked at my mother with relief, kept my eyes on what always pleased me. Here was the only object that did not seem strange or ugly or inauspicious to me.

Mrs Slade must have planned that our first lunch should have an Eastern flavour throughout, for we finished with tinned mangoes. The long spoon-shaped slices swimming in syrup disappointed me, because the preserving had made them taste more like peaches than anything else, but I had a second helping, since Mrs Slade seemed to expect it.

Afterwards Phyllis took me out into the paddock to show me her pony. A groom brought it out, but then left us alone together. I was feeling at a disadvantage, because Phyllis had changed into riding-breeches and looked even tougher and more self-sufficient than before. I thought too that I would probably be expected to ride as I was, in shorts, which would mean two raw patches on the insides of my legs. And what if I should fall off, or show any sort of fear? Phyllis would just look away, hardly even bothering to be scornful. The visit to the paddock was an ordeal.

Phyllis stood for some time with her arm on her pony's saddle, doing nothing. The running together of her thick eyebrows gave an effect of frowning, but I think she was really looking at me with no expression at all. At last she said: 'Are you fond of riding?' She might have been asking if I liked cleaning my teeth or performing some other irksome duty.

'Yes, last year I rode every week,' I explained, 'but now we are living in London.'

At this Phyllis gave my bare knees a glance and remarked: 'But you haven't got any breeches'; then she swung herself on to the pony and trotted briskly to the other end of the field.

I watched her go, wondering how soon I could leave without seeming rude. I wanted to explore the grounds by myself.

As she returned, I tried to show some interest, but Phyllis passed without a word. Her face was set; she might have been all alone. I felt that my welcoming smile must look silly indeed.

Several times she rode round the field, solemnly, without taking any notice of me; I was only saved from the growing awkwardness of my position by the sudden appearance of Mr Mellon and Mrs Slade. My eyes had wandered towards the house rather longingly; and then I had seen what looked to me like the strangest of little horseless carriages. It was approaching down one of the winding yellow paths, threading in and out of the trees very rapidly and smoothly.

Soon I could see that it held Mr Mellon with Mrs Slade sitting at his feet. Mr Mellon waved his hand, as if beckoning, so I ran to the gate of the paddock and let myself out.

They had stopped in the protection of a bank of shrubs with mottled leaves, and against this bright yellow and green background their faces looked very pale. I saw that the little carriage was an elaborate motor or electric bathchair. Mr Mellon's head was framed in the folds of the calash hood, while Mrs Slade squatted cross-legged on the tiny space left on the platform in front of his feet. Seen thus, sitting before him like a little Buddha, she was stranger than ever to me; but I also thought her smile seemed happier and more spontaneous, as if she really enjoyed fitting herself so ingeniously into the bathchair and racing down the garden paths with Mr Mellon. She suggested that I might like to try riding in her position and rose from the platform like a dancer, hardly using her hands, and with her legs still crossed. Mr Mellon said: 'Yes, you just see if you can fit in as neatly as Mrs Slade, and then we'll go for a fine ride.'

I crouched on the platform uncomfortably, afraid to lean back for fear of hurting Mr Mellon's legs, or of feeling them against me. I imagined terrible skeleton legs that could not bear

even the lightest touch. Mr Mellon turned the chair round and we began to glide almost silently towards the house. We passed Phyllis, still riding round the paddock. Mr Mellon waved; she gave us a glance, seemed to take in the fact that I was sitting at his feet, and returned one wooden gesture.

'I expect you and Phyllis get on like a house on fire,' Mr Mellon said: 'she's as good as any boy at riding and playing games. You should see her throw a cricket ball!'

Again I wondered that Mr Mellon could show such fondness for Phyllis; she seemed so very unenticing to me.

We were now passing the house and reaching the wooded ground behind. As soon as the path began to rise a little Mr Mellon said: 'I know I told you about the white elephant that lives at the top, but we'd better not go to see him today. It's not very good for the chair to pull two uphill, and I expect Mrs Slade's wondering where we've got to.'

I was only too pleased to drop the subject of the white elephant and agreed that we ought to go back at once; but when we were near the front door, Mr Mellon suggested leaving me, so that he could go back to Mrs Slade and bring her up to the house in the chair.

As I wandered into the hall, I thought dimly that Mr Mellon also enjoyed riding in the chair with Mrs Slade. It might be one of their chief pleasures. I knew he admired her for being so small and supple that she could fit on to the footboard where no one was supposed to sit. I wondered if they ever went out of the grounds in the chair, taking a picnic perhaps and a book; and if they did go out, did people stare to find her sitting there at his feet like an Eastern idol?

How quiet the house was! I guessed that my mother had gone upstairs to write letters or to read on her bed. I began to want to know about the other rooms leading off the hall. I had only seen Mr Mellon's room and the dining room. Very gently I opened one of the heavy mahogany doors and found myself in

what must have been the drawing room. The first thing that caught my interest was a cabinet filled with Japanese and Chinese ivories; some too large to have been made out of only one tusk. There was a smiling woodman with a basket of sticks on his back; a woman in fantastic ceremonial dress; then I saw it – a man crouching down, holding out one hand beseechingly. He must have been a beggar; he was naked except for a few rags and so wasted that there seemed to be no more than a film between me and his tiny skeleton. It was a moment before I realised that the little creatures running over him were rats and that they were gnawing his flesh. The carver had shown the tears in the skin, the rats' minute beady eyes, the teeth of the agonised man. Looking deeper into the open mouth, I saw even a tongue curling back convulsively.

What a horrible thing this delicate ivory was to me! How could anyone carve such hideousness so lovingly? How could another human being be found to possess it? And yet the little figure fascinated me; I had to turn it over in my hands until every detail had been taken in; then I shut it back into the cabinet and left the room tingling.

Tea was being laid out on small tables in Mr Mellon's room; I went in and found my mother already there. I wanted to tell her about the little starving man, to take her into the drawing room and show it to her quickly before the others returned; but something held me back. It was as if the sight were indecent and I did not dare to share it with her.

Soon we were all eating scones and guava jelly, sandwiches of several different sorts, and little cakes brightly decorated with silver balls, crystallised violets, rose petals, and little spikes of angelica. Mr Mellon said to me: 'You'll want to be with Phyllis again after tea; grown-ups aren't nearly so much fun, are they?'

I wriggled, trying to think of something to say that would not slight Phyllis, yet show that I preferred the company of the grown-ups.

When tea was over, I managed somehow to get out of the room alone. Perhaps I put on the grave air that children assume when they want to be 'excused.' Once free, I waited in my room until I felt that Phyllis had settled to some amusement without me; then I stole downstairs again and let myself into another of the unknown rooms.

This one was a sort of study, or perhaps, because of its size, it might have been called the library, although books were not the most important part of its furnishing. A huge roll-top desk stood in the middle of the room and round this were spread all types of wild animal skins: lions, tigers, leopards, polar bears, brown bears. All their heads were mounted, with fierce glass eyes staring, and pink plaster tongues, rough as sandpaper, hungry for the taste of blood. These roaring mouths seemed just to have loomed up through the floor, so that I could imagine the flat skins gradually filling and taking shape after them, until I would be surrounded by living wild beasts.

'But how can Mr Mellon wheel his chair in here with so many heads on the floor?' I thought; then I began to notice how unused every object in the room looked. The books were all shut away behind glass in the rather small bookcases. There were no magazines lying about. The ashtrays glistened. Even the blotting paper on the desk was almost without ink stains.

I sat down on the polar bear and had begun to ponder again on the peculiar deadness of Mr Mellon's possessions, when the door opened softly and my mother looked in.

'Darling, don't prowl so,' she said, coming across to me, still rather quietly; 'they might not understand how fond you are of things. They might think you were being too inquisitive.'

'I expect they think I'm playing with Phyllis,' I answered.

'Well, anyhow, let's say good night and go upstairs now; it is nearly your bath time.'

'But Mummy, have you ever seen so many animals with

stuffed heads in one room before?' I asked, to keep her for a few more minutes from taking me to bed.

Should I try to hold her interest by telling her about the little rat-eaten ivory beggar? But once more I put the idea from me.

When I was bathed and in pyjamas and dressing-gown by the imitation logs that glowed so rosily on the hearth in my room, I said: 'Mummy, who will have Mr Mellon's snuffboxes when he dies?'

My mother frowned a little.

'We don't want to think about people dying.'

'But I want to know,' I persisted.

My mother seemed to be wondering whether to tell me something or not.

'Has Phyllis explained that Mr Mellon is going to adopt her?' she asked, lifting her eyebrows.

'No, Phyllis hardly says anything at all.' Then the full meaning of my mother's words came to me and I added excitedly, 'Will *she* have the snuffboxes and everything then?'

'I expect so, darling, but it won't be for a long time, so don't talk about it or think about it any more.'

But once in bed, with the lights out, I thought of nothing else. It seemed to me the greatest waste that Phyllis should have anything more than the necessities of life; then my imagination was caught by the wonderful change in her fortunes; for, without having heard a word on the subject, I pictured Mrs Slade and Phyllis in very difficult circumstances before they had come to Mr Mellon.

I must have been asleep for some hours when I was woken by soft bumping sounds and the murmur of voices. The noises frightened me and even after I had recognised one of the voices as Mrs Slade's, I felt anxious. What could be happening? There was another gentle bump. Mrs Slade said: 'There we are! Up at last!' and I heard a sort of comfortable grunt from Mr Mellon.

I realised she was wheeling him to bed. Could she have pulled him up the stairs alone? The stairs were shallow, but Mr Mellon would be very heavy and awkward in his wheelchair. It did not seem possible for so small a woman. Perhaps the Indians had helped, and now she was only manoeuvring some odd steps on the landing. They passed my door, still talking in undertones. Mrs Slade's singsong voice was murmuring comforting things, as if she were talking to a child; Mr Mellon just grunted, or replied in monosyllables.

Their intimacy surprised me, for even while riding in the bathchair together there had been some formality; and, before that, I had thought them quite cut off, in spite of Mr Mellon's jolliness and Mrs Slade's metallic smiles. Now they were like two old friends who no longer had to be very polite. It is true that Mrs Slade still sounded dutiful for I remember thinking, 'She hasn't finished yet!' but it was the dutifulness rather of an old nurse than of a professional hostess.

Long after all sound of them had ceased, I felt haunted. My mother's sudden giddiness in the train had fixed my mind on pain and illness, so that I had been made specially conscious of Mr Mellon's useless legs; then I had crept into the drawing room and seen that terrible starving man gnawed by rats. The fearful feelings awakened in me, together with what I thought of as the great ugliness and deadness of Mr Mellon's surroundings, made me long for tomorrow when we would go back to London. Everybody had been kind, even Phyllis had meant no harm, and yet I wanted to draw away from all of them.

Only the jewelled boxes and the wonderful curry were truly happy memories.

I did not see Mr Mellon again for about six years. During this time he had moved to a house of his own building, a few miles from his old villa. My mother was no longer alive, and I paid this second visit with my father on a hot summer's day.

The approach to the house had lately been planted with all kinds of ornamental shrubs and trees, ranging from green through yellow to pink and greyish blue. I found myself contrasting their gay feathery leaves with the dark glistening toughness of the monkey-puzzles and rhododendrons at the villa. The drive was so thickly planted that I could see nothing of the rest of the garden, nor did the house come into view until we were almost upon it.

It was long and low, only one storey high, built of a light pinkish-fawn brick, with metal casements; apart from its squatness, the sort of house that any prosperous business man might build. When the door was opened by an English servant, I grew even more disappointed. What had happened to the Indians? Was nothing strange left? I began even to regret the ugliness which had disquieted me as a child. I would have found it stimulating now.

My eyes brightened when we were taken into the room where Mr Mellon sat, for it was octagonal and the floor was an inlay of rubber in baby blue and pink and yellow; it reminded me of nothing so much as the top of some gigantic cake prettily decorated with soft icing.

As I walked forward to shake hands with Mr Mellon, I felt its slight resilience.

Three sides of the octagon were of glass, and Mr Mellon's chair stood so that he had the whole of the garden before him. While he was welcoming my father boisterously I stood looking out of the window in some wonder. It was a complete surprise to find the house built almost on the edge of a small ravine. The garden fell away at once in narrow terraces, held back by large flat rocks. More pointed rocks thrust out of the ground, and a path with stone steps wound in and out of these until it reached smooth lawns and a stream at the bottom. A small rustic bridge led to the other heavily wooded bank, where the ground sloped away more gently.

'Not bad, eh?' said Mr Mellon, suddenly taking notice of my interest; 'you'd never think we had anything like this here, would you? I must say the landscape gardener has made a good job of it – really a very clever chap.'

My father went to the window to admire the scene, so that both our backs were turned when Mrs Slade came in with Phyllis. I was the first to hear their footsteps. Mrs Slade, like Mr Mellon, seemed hardly to have changed at all, but Phyllis had grown into 'a breasted woman,' as I put it to myself. Her arms and legs were beefier than ever, and she was much taller than myself. But the full bosom gave me the greatest shock. I thought of her as the mother of fat twins. And was that *lipstick* on her mouth? Were girls who were not yet sixteen ever allowed to wear lipstick? Apart from this sudden redness, her face was much as I remembered it. True the eyebrows had become even thicker, leaving no sign that the long fat caterpillar had ever been two smaller ones affectionately rubbing noses. The expression too had strengthened; the sullenness was now almost formidable; but I was quick to see again that it was misleading, that it arose from her eyebrows and from her quite unmalicious indifference to other people.

As soon as Mrs Slade had greeted us with many smiles and bright remarks, and Phyllis had nodded her head and held out

her thick hand, Mr Mellon suggested that we should be shown the house and garden.

'Oh, yes,' said Mrs Slade to my father, 'you've never been to this house before, have you? We like it so much now that it is finished at last. It is much more convenient than the old one; there are no stairs you see; Mr Mellon can wheel himself wherever he likes without having to call anyone. All the floors are rubber to make things as quiet and comfortable as possible; I wouldn't have anything else now; they are so bright and so easy for the maids to keep clean.'

Still chattering, Mrs Slade led us into the garden first, to give us an appetite for tea, as she explained. She knew very little about the flowers and rock plants, but she kept drawing our attention to things by saying: 'Aren't those pretty?' or 'Mr Mellon's very fond of that,' or again, 'I think this is rather rare, but there's nothing much to show for it, is there?'

My father was walking with Mrs Slade and I with Phyllis, but since Phyllis said so little, I found myself listening chiefly to the other conversation. I heard Mrs Slade tell my father about the number of men it had taken to move some of the rocks into position.

'But weren't they already here?' my father asked in surprise.

'Oh no, nothing was here – only the banks and the stream.'

Mrs Slade's voice was very high and fluting; she seemed to be amused by my father's simplicity on the subject of gardens.

'Of course,' she went on, 'this is not a very good garden for Mr Mellon, most parts are so steep; but he took a great fancy to the site and *would* have the house here.'

'Do you like school?' Phyllis suddenly asked, bringing me back to her with a jerk.

'Yes,' I said hurriedly and quite untruthfully; 'do you like yours?'

'It's all right; some of the mistresses are a bit dim. I needn't stay after next term though, if I don't want to. Mello says I can

go to a finishing school abroad – I can choose where.'

'So she calls him Mello,' I thought; 'and they're going to let her go to one of those schools where the girls just do what they like!' This further proof that Phyllis was being treated almost as a grown-up filled me with envy. How I longed to have some attention paid to my own private wishes!

We had now reached the bottom of the cliff garden; Mrs Slade led us across the strip of lawn to the rustic bridge. I leaned on the gnarled balustrade and looked down into the water. It seemed quite shallow.

'Oh, do you know what Mr Mellon has had done?' she asked, as if here were a topic, of especial interest to men, that had been almost overlooked; 'he has had the stream stocked with trout. There are gratings underneath the water at the boundaries of Mr Mellon's land so they can't swim away. We are hoping they will settle down and have lots of families.'

I now caught a glimpse of a dark shape fanning the water with its silky tail. It held its position under the far bank; then darted away in a flash, leaving me to search for others. I thought of their bodies, soft as moleskin and with a sort of filmy shimmer over them, perhaps a little like the bloom on untouched plums. I knew very little of trout and probably confused them with my memories of lovely prune-coloured carp.

But I was not allowed to gaze into the water for long; Mrs Slade told me to cross over and look up at the terraced garden and the house.

'It is rather a good view,' she said; 'someone told Mr Mellon it was like the hanging gardens of Babylon, but I don't know how he knew.' She gave her little tinkling laugh.

Far away I could see Mr Mellon in his great bow window; he looked like a captain on the bridge, I thought – a captain who had sat down and given up worrying about his ship.

After a moment he saw me too and waved. He was smiling broadly, as if I had done something to amuse him. I waved back;

he took out his handkerchief and pretended to be a boy scout signalling. I wondered how long I ought to keep my eyes on him.

'We'd better not go any further now,' Mrs Slade was saying to me; 'there is much more to show you, but it's rather a stiff climb back and you'll be wanting tea; perhaps your father will be able to bring you over again quite soon.'

Crossing the stream rather reluctantly, I started to walk beside Phyllis again. In spite of my envy, I felt warmer towards her since our slight talk; we had never exchanged so many words before. I tried to begin another subject.

'Can you bathe in the stream?' I asked.

'Not now the trout are in it.'

Her tone made me feel I ought never to have asked such a question.

'Mello says they mustn't be disturbed.'

'Does Mr Mellon ever fish for them?'

'Oh, no, he never goes down there.'

'Who does fish then?'

'Nobody's allowed to until the fish have had babies; they've got to settle down.'

'Well, who *will* be allowed to fish?' I persisted, rather hopelessly.

'Oh, I don't know, people who come, friends of Mello's, I suppose. He might let you, if you come next year.'

Phyllis paused after this last remark; I realised suddenly that she was about to tell me a secret.

'As a matter of fact I *do* sometimes bathe, if you'd really like to know,' she said grandly; 'there's a place where the trees lean over the water; I take off all my clothes and go in there – with nothing on,' she added, to make sure that I understood her fully.

She was looking at me, trying, I think, to find out the effect of her words. Did she want me to be confused and red? Or was she hoping for a lively interest in her nakedness? Perhaps she only wanted me to admire her devil-may-care attitude towards

33

Mr Mellon, the carefully nursed trout, and the curiosity of the gardeners.

It was difficult to return the gaze of those sulky eyes. The thick red lips were set as though carved out of wood and painted. The whole face had the relentless quality of some Polynesian image, of African ju-ju. I felt that the only protection was for me to make my face as mask-like as her own. I tried to do this, and when she saw that I had nothing to say, she began speaking again herself.

'Of course, it's not much fun, you can't really swim, it's too shallow; I just splash about.'

'Aren't you afraid of being seen?' I asked, as colourlessly and casually as possible.

'Oh, the trees make it quite private, but I wouldn't care much if one of the gardeners did come along. He wouldn't tell. Even if he did, Mello would only be a bit angry at first about his fish. I could get round him; he lets me do what I like.'

This was spoken as we climbed the last few steps to the house. I was afraid that Mr Mellon might hear through the open window, but Phyllis did not even trouble to lower her voice.

My father and Mrs Slade had sunk down on one of the stone seats of the terrace, and when Mr Mellon saw how hot my father was from the climb, he called out: 'You'll want something instead of tea, I can guess!'

My father laughed and shook his head; but I think he was very pleased to see whisky and soda appear with the tea tray.

As soon as everything had been brought and we were left to ourselves once more, I turned to Mrs Slade and asked what had happened to the Indians.

A bright stare came into her eyes, she held her neck so stiffly that barely perceptible tremors ran up to her head.

'Oh, we had to get rid of them,' she said, with careful smiling unconcern; 'they were good at first, but we found that the cook was awfully extravagant – then we had trouble with one of the others.'

There was a sudden gleam of fierceness in the soft brown eyes, as if some memory had stung her; the next moment it was drowned in smiles which asked me to believe that the Indians had been nothing but an amusing trivial episode. I wondered why the thought of the Indians should have excited Mrs Slade; I guessed that she had been worsted in some scene with one of them, and that her Eurasian blood still felt the outrage. I had never seen her angry before; there had been a sort of quenched anxiety and a preoccupation with the details of the day, but her attitude to other people had seemed unchanging. In public at least she treated her daughter and Mr Mellon with the same brittle sociability that she accorded to little-known guests. I remembered how as a child I had been disquieted both by her Eastern appearance and her mechanical smiles, and now a little of the uneasiness returned. I saw her as a woman who hid so much that when a spark of feeling did escape, it flashed with all the rage of the fire within. This rather sensational picture of her made me want to turn away from the long oily eyes, and the creamy cheeks that were too soft. I wanted the reassurance of my father's sleepy good-nature; even Mr Mellon's embarrassing heartiness and Phyllis's silences were refreshing.

We sat long over tea – my father and Mr Mellon had begun to talk about the past; and so little time was left for our inspection of the house. I felt disappointed as we hurried down a wide gallery, glancing into room after room almost without pausing.

I remember chiefly the variously patterned rubber floors, the monotonous primrose and chromium of every fitting in the kitchen, and the fantastic decoration of the bedroom which Mrs Slade laughingly said should be mine, when I came to stay, since I was fond of 'artistic' things.

The modern four-post bed had a pagoda roof with little wooden bells under the curling eaves; it was painted in dull blue, pale meat-red and yellow ochre, and all the mouldings were picked out in gold. On the dusty mauve walls large dragons

coiled towards each other ferociously; their teeth and scales were also gilded. The chairs had elaborate lattice-work backs. Everything was so new, so matte, so European in spite of all Chinese hankerings, that I was reminded at once of some painted backcloth for *Aladdin* which I must have seen as a child; the furniture and walls had the same powdery distemper bloom, and the designs the same coarseness as the bold scene-painting.

Here, as in every other room, I looked for the little ivory carving of the starving man that had so horrified me on my first visit to Mr Mellon; but it was nowhere to be seen; I doubt if it could have been found, even if I had not been so hurried; for everything was changed in this new house. Nearly all the floors, walls, and hangings were in the pale shades associated with babies, powder-puffs and sugared almonds, just as the shrubs in the drive had the light feathery leaves that I had never seen at the villa. There everything had been rigid and glistening and tough, here all was downy, almost scented – even the fantastic things were in pastel colours. But in spite of all changes, something of the villa's atmosphere remained. As we walked back to the octagon room to say goodbye to Mr Mellon, I tried without success to define what spirit it was that still lingered under the soft prettiness.

Mr Mellon was gazing out of his huge window and taking snuff; I saw him for a moment through the crack of the door before he was aware of us. His face was quite blank and empty, more than ever like a peeled trunk of wood. The welcoming smile that suddenly puckered all the features gave me a stab of discomfort, so that I wished I had not caught him as he was alone.

'Seen most things?' he called out with rowdy boyishness.

There was a flash of light as he put his jewelled box away.

'Pity you hadn't more time. All the more reason why you must come again.'

He put his hand up to my shoulder to say goodbye; then perhaps because he could no longer treat me as a child and hug me,

he stretched out his other arm and caught Phyllis, who was moving towards the terrace. She allowed herself to be drawn to him with her usual seeming ill-grace; he encircled her waist, swung her gently on her feet and gave her stomach a loving pat or two.

'We'll want to see him again very soon, won't we, Phyl?' he said.

Phyllis grunted.

I was becoming more and more uncomfortable when the opening of the door created just the slight diversion necessary for a not too unnatural escape. As soon as the heavy hand was taken from my shoulder, I turned, to see a new face hovering in the doorway.

'Yes, what is it, Bob?' asked Mrs Slade, brightly.

'Oh, excuse me, madam, I came to see if Mr Mellon was ready for his massage; it's his time.'

'In a minute, Bob, in a minute,' Mr Mellon called from the other end of the room.

'Yes, sir,' Bob said, and shut the door.

There had just been time for me to take note of Bob's curling fair hair, pink-brown colouring, and pursy cheeks. These last gave to his face the cast of an earlier century. His eyes seemed to stare a little, as though the lids were not quite full enough to cover them. He was near enough to my own age to make me conscious of his body under the white coat and dark trousers. It was as if I were asking myself: 'Will I look anything like that in four or five years' time? Will I have thick legs, thick arms, deep chest? Will I look so well-fed and strong?'

He appeared to be a favourite of Mrs Slade's, for she turned to me and said: 'You've not seen Bob before, have you? He's a very nice boy; he first came only as a valet; then we had him trained as a masseur, and now, although he's only nineteen, he does everything for Mr Mellon. It is an excellent arrangement.'

Mrs Slade might have been talking to herself, or to an intimate woman companion, instead of to a young boy; I realised

that my appreciation of Bob would not satisfy. She wanted real enthusiasm.

Mr Mellon held Phyllis till the last moment, then, as we were leaving the room, he released her with a playful spank, saying: 'Off you go, Phylly, to wave goodbye.'

But Phyllis did not run forward to escort us to the car; she ambled along, some way behind her mother.

My last picture was of her leaning against the open door, while, in the hall behind, Bob hurried back to the octagon room to begin his master's massage as soon as possible. Mrs Slade was showering us with busy smiles and hand-wavings. The car started, we turned and were quickly lost in the feathery trees.

III

Once more Mr Mellon, Mrs Slade and Phyllis disappeared from my life; I did not even hear of them, or if I heard, I quickly forgot the slight mention of some unimportant detail. But when I was nineteen, a new friend at the art school asked me to his parents' home for Easter, and I accepted impulsively.

So one grey evening I found myself in a little Sussex village, standing on an unknown doorstep, feeling very reluctant about ringing the bell.

I need not have been anxious about my visit, for the house was comfortable and my friend's mother seemed really pleased to see me.

She had just returned from Egypt; it was clear that her husband and son had not listened to her experiences with nearly enough interest; she was delighted to be able to pour all her stories into a new ear, to have a listener who paid attention and seemed to want to know more.

When asking me to stay, my friend had said rather brutally: 'My mother's an awful fool, you know.' Perhaps she did show more capriciousness and wilfulness than is quite acceptable; but in spite of these slight signs of childish whining or petty tyranny, we were soon on very good terms, even going off together to explore churches and a ruined abbey, while the others stayed at home.

When we came back from these expeditions, my friend would look at me as if he were wondering how I could have borne his mother's company for a whole morning, or afternoon. I imagined that the father also flashed glances at me sometimes; he seemed to be looking for signs of weariness or irritation, and because he could not find them, he was grateful, more polite than ever, yet somehow less friendly. It was as if he were relieved to see my easiness with his wife, but felt cut off from real communication with me just because of it. I had the vague notion, perhaps quite fanciful, that both father and son would have preferred it if I had appeared to enjoy myself less.

On the fourth or fifth day of my visit, John's mother announced at breakfast that there was to be a tea party in the afternoon. Extravagant groans came from John and his father, and once more they made me feel that I too ought to be pulling some sort of disapproving face instead of wearing the ridiculous smile of the perfect guest, pleased at any suggestion, however inane.

Both John and his father had threatened to go out; but as the time for the guests to arrive drew near, I noticed that they were looking trim and fresh, as though their faces had been dipped in cold water, their hair brushed vigorously and their ties straightened.

Tea for so many people had been laid on the long dining-room table, and I was placed next to my hostess.

'Come and sit near me and help me with the teacups,' she had called in her soft screech; 'John is no use, he only thinks about his own stomach.'

At first I had little time to listen to conversation because I was walking round the table with cups of tea and plates of buttered toast and scones; but when I came back to my place, the fluting, warbling tones of the woman on the other side of John's mother caught my attention. There was the faintest suggestion of the electric guitar about her voice.

'But, my dear,' she was saying, 'you should have been there; it was fantastic, but quite fantastic! In all our eighteen months of house-hunting we've never come across anything like it. All the floors were rubber; I had the awful feeling that I was trapped in a gigantic lavatory; it was terrifying. One room was fitted up as a sort of teahouse in Chinatown, another was sexagonal, I think, if there is such a word, and it doesn't sound too rude; anyhow, all these six or more walls seemed to close in on one, and there was an enormous window which just screamed out for one of those horrible dentist's chairs.'

At first her words floated in a void, but as the description grew, they seemed to link up with something in my own experiences; I began to listen intently.

She was talking of the garden now.

'Darling, even the plants were weird, and there were *the* most enormous rocks – rather marvellous really, if they hadn't seemed so completely out of place. The money that must have been poured into that garden!'

Surely there could be no more doubt? It was Mr Mellon's house and garden that were being so cruelly described. I realised for the first time that, since we were so close to the border, Mr Mellon's place in Kent could only be five or six miles away at the most. Feeling angry with this unknown woman for laughing at tastes that I myself had always thought strange, I decided to go over to see Mr Mellon as soon as possible; then it came back to me with a shock that she had been talking of a house that was to let or for sale, an empty house, whose key, decorated with a large label, must hang on one of the local house-agent's hooks.

Where had Mr Mellon gone? Was he at this moment building another house somewhere else? I suddenly wanted to know all that had happened since I last saw him.

While the woman was describing the house and garden, John's mother had not spoken, but her eyes had danced. Now the words came pouring out.

'But Dulcie, didn't you know? Didn't anyone tell you about that house?'

'Oh no, *do* tell me, I haven't heard a word. Is it haunted by some horribly unclean spirit? Or has *the* most atrocious murder been committed there? I can believe anything, *anything*.'

'No, it wasn't a murder, but the place is quite possibly haunted by now,' said John's mother with satisfaction, her eyes dancing more than ever. A faint flush had come into her cheeks.

She was in no hurry to reach the climax of her story; she seemed to wish to savour both her own excitement and the suspense of her audience.

'Perhaps you wouldn't have heard of it,' she mused; 'perhaps it *is* rather a local tragedy.'

'Darling, stop maundering! I'm mad to know what happened.'

'Well, you remember the rock garden?'

'Yes.'

'And the path leading down to the stream?'

'Yes, yes, pet, don't be so ponderous, I remember it all perfectly.'

'Well, one day the housekeeper ran down the path, jumped into the stream and drowned herself.'

The words seemed to tumble over each other, as if John's mother had suddenly grown tired of trying to unfold her story skilfully. For a moment I could not grasp their full meaning, then the exclamation: 'It's Mrs Slade, she means Mrs Slade!' kept ringing in my head like some battle cry from a famous poem.

'But why did she drown herself?' the woman was asking, 'we must know *everything*.'

John's mother beamed gratefully.

'Of course I didn't know them myself, but I've heard little bits from people who did; they've all said that it was the queer-est household. The man was an invalid. He seems to have been

very good indeed to this housekeeper, who was half-Japanese or something of that sort; he had even adopted her daughter.'

The woman called Dulcie raised her bald-looking eyebrows.

'Yes, I thought that rather an interesting point, too,' said John's mother, 'but anyhow, when this daughter suddenly eloped with the chauffeur, the mother was so upset that she just flung herself into the stream; and I'm told that it's only quite shallow. One of the gardeners found her later.'

Something had mounted from my stomach to my heart, to my head. Perhaps I had turned very red. I looked at my hostess's bright chirpy smile and understood why her son thought her so silly. Now that she had told her story she was like a bird waiting for crumbs. Her head was cocked a little to one side; she seemed to be contemplating her own winsomeness, to be modestly disclaiming any credit for the suicide which had interested us so much.

Through the surge and tingle in my head, I found myself asking her if she was sure that the daughter had run away with a chauffeur.

'Someone like that,' she said, a little piqued to have her story questioned; 'actually, now you ask me, I believe I did hear later that he was more the personal servant of the old man, the sort of valet-nurse.'

'Was he called Bob?' I asked, unable to stop myself.

'How should I know?'

John's mother was staring at me curiously. She was about to ask if I knew the family. I picked up a plate of little cakes and started to pass them round the table. When the question came, I pretended not to hear but I answered it under my breath, to myself, 'Yes, I knew them, but not very well. She wasn't half-Japanese, she was half-Javanese – I expect it was Bob who ran away with Phyllis; I only saw him once for a moment, but I can imagine it so easily with him. It must have been Bob.'

People were already beginning to leave the table, to wander into the other room or talk in groups near the windows.

I decided to put down my cakes on a side table and escape into the hall.

I was out, and nobody had called my name or appeared to notice me. I could hear the chatter and smell the cigarette smoke creeping under the door. It was still quite light outside; I opened the front door and let myself into the garden.

I walked behind hedges until I came to the old stables; there I found John's bicycle and began to pump the tyres. I tried the lamp and saw that the battery was fairly new. That was good. I would need it.

By great good fortune I found my way without a mistake to the village nearest Mr Mellon's house; after that my progress was more difficult. But at last someone directed me down the right lane; I came upon his drive, and had almost passed it before something told me to look again. Yes, that was the drive; the trees and bushes were bigger, but I could recognise them.

It was dusk now; objects were beginning to lose their colour and sink into each other, like lead soldiers melting on the nursery fire. I saw an orange square of light somewhere through the trees and wondered if a caretaker lived there. I was suddenly afraid of being discovered in Mr Mellon's grounds. What explanation of my prowling could I give? I remembered my mother saying: 'Darling, don't prowl so.'

Pushing my bicycle into the shrubs, I walked swiftly down the drive till I came to the point where it turned and one saw the long squat house. I stood still, shocked by the blankness of the windows; they were oblong eyes over which a terrible fungus of nothingness was growing. And the porch was a great black mouth, the jaws of the whale that swallowed Jonah, the gates of Hell in an ancient wall-painting. I could not walk into the yawning cadaverous blackness under that plain brick arch; I could not even look through those neat metal casements, now that they had been turned into horrible eyes filmed with cataract. I stood back from the house, staring through its walls, picturing

Phyllis and Bob as they prepared for flight. Phyllis would be packing everything of value into a small soft suitcase, while Bob waited rather desperately by the door. She would put in all the jewels and trinkets Mr Mellon had ever given her. She would be methodical, heavy, placid; but Bob would be pulling at his collar and jerking down his sleeves. His large eyes would roll from her to the door and back again. She would take no notice of his longing to be off, until the last object had been fitted in.

Because I knew nothing of them as they were today, because I did not even know for certain that it was Bob who had gone with Phyllis, my picture seemed squalid and meaningless and dead. It was the counterfeit of a counterfeit. The bare fact that Phyllis had run away with a lover was in itself papery and unreal. I had been given no reason, only told that it was so; therefore my mind kept teasing and plucking at ideas.

At last I made myself turn from them and from the house; I would strain no more after reasons, just let thoughts float through my head, while I wandered in the garden.

It was a relief to plunge into the bushes. Somehow they were not fearful, as they might well have been at nightfall; they seemed to offer warmth, a protection against the balefulness of the house. I pushed and threaded my way blindly, till I came out on a ridge of the ravine, some way from the house. To the left I could see the great window of the octagon room gleaming palely against the sky. There was no proper path here, only a sort of gardener's track along the ridge. I walked to the end, then began climbing down from terrace to terrace, avoiding the plants by standing on the rocks. The garden was still being tended; I could see patches of softly crumbled, weedless earth. Birds were scudding across the sky, calling forlornly, as though the coming of night were some sort of catastrophe for them. When I reached the foot of the ravine, I was hot and tired; sweat had begun to sting in the scratches I had received from the shrubs and trees. I sat down on a rock enjoying the cold moistness that was already

coming from it. The stream flowed near me, industriously, secretly, like some man who, thinking he is alone, sings and mutters and swears at his work.

I sat listening for some moments, then stood up and walked towards the bridge. From the other bank I looked up the tortuous path. All at once I thought of Mrs Slade as she must have been when she ran down to drown herself. I saw her crying, crying, stumbling over the artfully uneven stone steps, chattering madly all the time. Nothing could stop her; if she fell, she was on her feet again in a moment, stockings torn, knees bleeding. She was like a wingless bat, wrapped round in a little whirlwind. Her greying hair flared out in a tangle wilder than Beethoven's; and her eyes had grown into pools of boiling tar. They were still growing; suddenly I was caught up in them, so that I plunged into the stream with her and heard them sizzle as we struck the water...

I was standing now on the very brink of the stream looking straight down into the black water. The night wind ruffled the surface into little fish scales. One of the birds kept up its perplexed lost flying and calling. Darkness was gathering in the branches of the trees behind me, thickening under the rocks, turning them into grotesques and derelicts standing in puddles of ink. One was a man with an elephant's trunk which he clutched to himself desperately. Another had huge monkey ears; all the rest of him had sunk into a belly like a giant's teapot. The biggest was an ancient pugilist who had given up hope and died at last by the side of the road. He was a vast lump of sagging muscles and despair.

High up above them the dark bow of Mr Mellon's window jutted out. I thought of him sitting there, taking snuff, staring blankly, waiting for Bob or Phyllis or Mrs Slade to come. I saw him as a great sick bird, a turkey wrapped in flannel. How long was it before he realised that he had been deserted by all three of them? Did he watch the gardeners bringing the body up the

twisting path? Where was he now? Had he found other people to look after him?

Then I remembered how fond he was of the stream, how he had stocked it with trout and told Phyllis not to bathe there.

And all the way up the cliff, back to my bicycle in the drive, I kept wondering if the fish had been very disturbed when Mrs Slade plunged in and drowned herself.

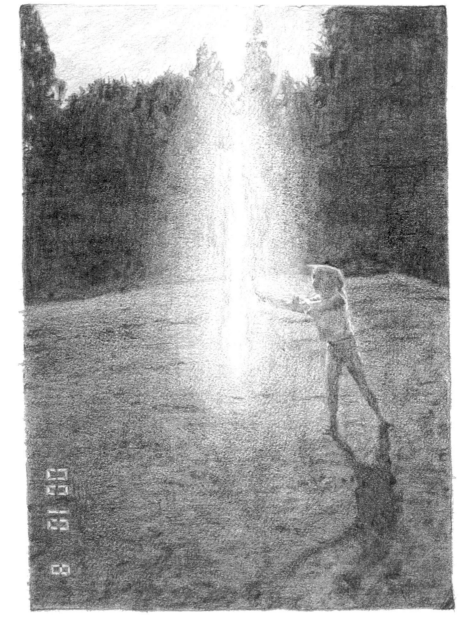

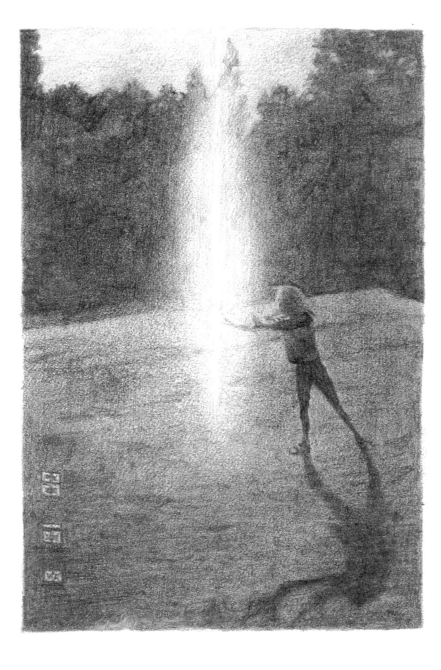

A STICK
OF
GREEN CANDY

The clay pit had been dug in the side of a long hill. By leaning back against the lower part of its wall, Mary could see the curved highway above her and the cars speeding past. On the other side of the highway the hill continued rising, but at a steeper angle. If she tilted her head farther back, she could glimpse the square house on the hill's summit, with its flight of stone steps that led from the front door down to the curb, dividing the steep lawn in two.

She had been playing in the pit for a long time. Like many other children, she fancied herself at the head of a regiment; at the same time, she did not join in any neighbourhood games, preferring to play all alone in the pit, which lay about a mile beyond the edge of town. She was a scrupulously clean child with a strong, immobile face and long, well-arranged curls. Sometimes when she went home toward evening there were traces of clay on her dark coat, even though she had worked diligently with the brush she carried along every afternoon. She despised untidiness, and she feared that the clay might betray her headquarters, which she suspected the other children of planning to invade.

One Street Las Vegas Nevada

One afternoon she stumbled and fell on the clay when it was still slippery and wet from a recent rainfall. She never failed to leave the pit before twilight, but this time she decided to wait until it was dark so that her sullied coat would attract less attention. Wisely she refrained from using her brush on the wet clay.

Having always left the pit at an earlier hour, she felt that an explanation was due to her soldiers; to announce simply that she had fallen down was out of the question. She knew that her men trusted her and would therefore accept in good faith any reason she chose to give them for this abrupt change in her day's routine, but convincing herself was a more difficult task. She never told them anything until she really believed what she was going to say. After concentrating a few minutes, she summoned them with a bugle call.

'Men,' she began, once they were lined up at attention, 'I'm staying an hour longer today than usual, so I can work on the mountain-goat manoeuvres. I explained mountain-goat fighting last week, but I'll tell you what it is again. It's a special technique used in the mountains around big cliffs. No machine can do mountain-goat fighting. We're going to specialise.' She paused. 'Even though I'm staying, I want you to go right ahead and have your recreation hour as usual, like you always do the minute I leave. I have total respect for your recreation, and I know you fight as hard as you play.'

She dismissed them and walked up to her own headquarters in the deepest part of the pit. At the end of the day the colour of the red pit deepened; then, after the sun had sunk behind the hill, the clay lost its colour. She began to feel cold and a little uneasy. She was so accustomed to leaving her men each day at the same hour, just before they thronged into the gymnasium, that now lingering on made her feel like an intruder.

It was almost night when she climbed out of the pit. She glanced up at the hilltop house and then started down toward the deserted lower road. When she reached the outskirts of

57

town she chose the darkest streets so that the coat would be less noticeable. She hated the thick pats of clay that were embedded in its wool; moreover she was suffering from a sense of inner untidiness as a result of the unexpected change in her daily routine. She walked along slowly, scuffing her heels, her face wearing the expression of a person surfeited with food. Far underneath her increasingly lethargic mood lurked a feeling of apprehension; she knew she would be reprimanded for returning home after dark, but she never would admit either the possibility of punishment or the fear of it. At this period she was rapidly perfecting a psychological mechanism which enabled her to forget, for long stretches of time, that her parents existed.

She found her father in the vestibule hanging his coat up on a peg. Her heart sank as he turned around to greet her. Without seeming to, he took in the pats of clay at a glance, but his shifting eyes never alighted candidly on any object.

'You've been playing in that pit below the Speed house again,' he said to her. 'From now on, I wanted you to play at the Kinsey Memorial Grounds.' Since he appeared to have nothing to say, she started away, but immediately he continued. 'Some day you may have to live in a town where the administration doesn't make any provision for children at all. Or it may provide you with a small plot of land and a couple of dinky swings. There's a very decent sum goes each year to the grounds here. They provide you with swings, seesaws and chin bars.' He glanced furtively at her coat. 'Tomorrow,' he said, 'I drive past that pit on my way out to Sam's. I'll draw up to the edge of the road and look down. See that you're over at the Memorial Grounds with the other children.'

Mary never passed the playgrounds without quickening her step. This site, where the screams of several dozen children mingled with the high, grinding sound of the moving swings, she had always automatically hated. It was the antithesis of her clay pit and the well-ordered barracks inside it.

58

When she went to bed, she was in such a state of wild excitement that she was unable to sleep. It was the first time that her father's observations had not made her feel either humiliated or ill. The following day after school she set out for the pit. As she was climbing the long hill (she always approached her barracks from the lower road), she slackened her pace and stood still. All at once she had had the fear that by looking into her eyes the soldiers might divine her father's existence. To each one of them she was like himself – a man without a family. After a minute she resumed her climb. When she reached the edge of the pit, she put both feet together and jumped inside.

'Men,' she said, once she had blown the bugle and made a few routine announcements, 'I know you have hard muscles in your legs. But how would you like to have even harder ones?' It was a rhetorical question to which she did not expect an answer. 'We're going to have hurdle races and plain running every day now for two hours.'

Though in her mind she knew dimly that this intensified track training was preparatory to an imminent battle on the Memorial playgrounds, she did not dare discuss it with her men, or even think about it too precisely herself. She had to avoid coming face to face with an impossibility.

'As we all know,' she continued, 'we don't like to have teams because we've been through too much on the battlefield all together. Every day I'll divide you up fresh before the racing, so that the ones who are against each other today, for instance, will be running on the same side tomorrow. The men in our outfit are funny about taking sides against each other, even just in play and athletics. The other outfits in this country don't feel the same as we do.'

She dug her hands into her pockets and hung her head sheepishly. She was fine now, and certain of victory. She could feel the men's hearts bursting with love for her and with pride in

their regiment. She looked up – a car was rounding the bend, and as it came nearer she recognised it as her father's.

'Men,' she said in a clear voice, 'you can do what you want for thirty minutes while I make out the racing schedule and the team lists.' She stared unflinchingly at the dark blue sedan and waited with perfect outward calm for her father to slow down; she was still waiting after the car had curved out of sight. When she realised that he was gone, she held her breath. She expected her heart to leap for joy, but it did not.

'Now I'll go to my headquarters,' she announced in a flat voice. 'I'll be back with the team lists in twenty-five minutes.' She glanced up at the highway; she felt oddly disappointed and uneasy. A small figure was descending the stone steps on the other side of the highway. It was a boy. She watched in amazement; she had never seen anyone come down these steps before. Since the highway had replaced the old country road, the family living in the hilltop house came and went through the back door.

Watching the boy, she felt increasingly certain that he was on his way down to the pit. He stepped off the curb after looking prudently for cars in each direction; then he crossed the highway and clambered down the hill. Just as she had expected him to, when he reached he edge of the pit he seated himself on the ground and slid into it, smearing his coat – dark like her own – with clay.

'It's a big clay pit,' he said, looking up at her. He was younger than she, but he looked straight into her eyes without a trace of shyness. She knew he was a stranger in town; she had never seen him before. This made him less detestable, nonetheless she had to be rid of him shortly because the men were expecting her back with the team lists.

'Where do you come from?' she asked him.

'From inside that house.' He pointed at the hilltop.

'Where do you live when you're not visiting?'

'I live inside that house,' he repeated, and he sat down on the floor of the pit.

'Sit on the orange crate,' she ordered him severely. 'You don't pay any attention to your coat.'

He shook his head. She was exasperated with him because he was untidy, and he had lied to her. She knew perfectly well that he was merely a visitor in the hilltop house.

'Why did you come out this door?' she asked, looking at him sharply. 'The people in that house go out the back. It's level there and they've got a drive.'

'I don't know why,' he answered simply.

'Where do you come from?' she asked again.

'That's my house.' He pointed to it as if she were asking him for the first time. 'The driveway in back's got gravel in it. I've got a whole box of it in my room. I can bring it down.'

'No gravel's coming in here that belongs to a liar,' she interrupted him. 'Tell me where you come from and then you can go get it.'

He stood up. 'I live in that big house up there,' he said calmly. 'From my room I can see the river, the road down there and the road up here, and this pit and you.'

'It's not your room!' she shouted angrily. 'You're a visitor there. I was a visitor last year at my aunt's.'

'Goodbye.'

He was climbing out of the pit. Once outside he turned around and looked down at her. There was an expression of fulfilment on his face.

'I'll bring the gravel some time soon,' he said.

She watched him crossing the highway. Then automatically she climbed out of the pit.

She was mounting the tedious stone steps behind him. Her jaw was clamped shut, and her face had gone white with anger. He had not turned around once to look at her. As they were nearing the top it occurred to her that he would rush into the house and slam the door in her face. Hurriedly she climbed three steps at once so as to be directly behind him. When he opened the door, she pushed across the threshold with him; he did not seem to notice her at all. Inside the dimly lit vestibule the smell of fresh paint was very strong. After a few seconds her eyes became more accustomed to the light, and she saw that the square room was packed solid with furniture. The boy was already pushing his way between two identical bureaus which stood back to back. The space between them was so narrow that she feared she would not be able to follow him. She looked

around frantically for a wider artery, but seeing that there was none, she squeezed between the bureaus, pinching her flesh painfully, until she reached a free space at the other end. Here the furniture was less densely packed – in fact, three armchairs had been shoved together around an uncluttered area, wide enough to provide leg room for three people, providing they did not mind a tight squeeze. To her left a door opened on to total darkness. She expected him to rush headlong out of the room into the dark in a final attempt to escape her, but to her astonishment he threaded his way carefully in the opposite direction until he reached the circle of chairs. He entered it and sat down in one of them. After a second's hesitation, she followed his example.

The chair was deeper and softer than any she had ever sat in before. She tickled the thick velvet arms with her fingertips. Here and there, they grazed a stiff area where the nap had worn thin. The paint fumes were making her eyes smart, and she was beginning to feel apprehensive. She had forgotten to consider that grown people would probably be in the house, but now she gazed uneasily into the dark space through the open door opposite her. It was cold in the vestibule, and despite her woollen coat she began to shiver.

'If he would tell me now where he comes from,' she said to herself, 'then I could go away before anybody else came.' Her anger had vanished, but she could not bring herself to speak aloud, or even to turn around and look at him. He sat so still that it was hard for her to believe he was actually beside her in his chair.

Without warning, the dark space opposite her was lighted up. Her heart sank as she stared at a green wall, still shiny with wet paint. It hurt her eyes. A woman stepped into the visible area, her heels sounding on the floorboards. She was wearing a print dress and over it a long brown sweater which obviously belonged to a man.

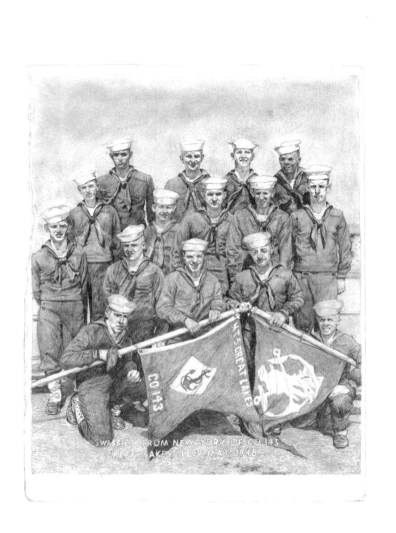

SWABBIES FROM NEW YORK OF CO.143
GREAT LAKES, ILL. 3 MAY 1948

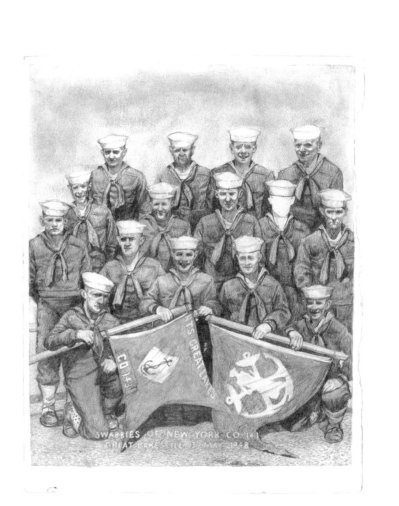

SWABBIES OF NEW YORK CO 141
GREAT LAKES ILL 1 MAY 1948

'Are you there, Franklin?' she called out, and she walked into the vestibule and switched on a second light. She stood still and looked at him.

'I thought I heard you come in,' she said. Her voice was flat, and her posture at that moment did not inspire Mary with respect. 'Come to visit Franklin?' she asked, as if suddenly aware that her son was not alone. 'I think I'll visit for a while.' She advanced toward them. When she reached the circle she squeezed in and sat opposite Mary.

'I hoped we'd get a visitor or two while we were here,' she said to her. 'That's why I arranged this little sitting place. All the rest of the rooms are being painted, or else they're still too smelly for visiting. Last time we were here we didn't see anyone for the whole two weeks. But he was a baby then. I thought maybe this time he'd contact when he went out. He goes out a lot of the day.' She glanced at her son. 'You've got some dirt on that chair,' she remarked in a tone which did not express the slightest disapproval. She turned back to Mary. 'I'd rather have a girl than a boy,' she said. 'There's nothing much I can discuss with a boy. A grown woman isn't interested in the same things a boy is interested in.' She scratched a place below her shoulder blades. 'My preference is discussing furnishings. Always has been. I like that better than I like discussing styles. I'll discuss styles if the company wants to, but I don't enjoy it nearly so well. The only thing about furnishings that leaves me cold is curtains. I never was interested in curtains, even when I was young. I like lamps about the best. Do you?'

Mary was huddling as far back into her chair as she could, but even so, without drawing her legs up and sitting on her feet, it was impossible to avoid physical contact with the woman, whose knees lightly touched hers every time she shifted a little in her chair. Inwardly, too, Mary shrank from her. She had never before been addressed so intimately by a grown person. She closed her eyes, seeking the dark gulf that always had separated

66

her from the adult world. And she clutched the seat cushion hard, as if she were afraid of being wrenched from the chair.

'We came here six years ago,' the woman continued, 'when the Speeds had their house painted, and now they're having it painted again, so we're here again. They can't be in the house until it's good and dry because they've both got nose trouble – both the old man and the old lady – but we're not related. Only by marriage. I'm a kind of relative to them, but not enough to be really classed as a relative. Just enough so that they'd rather have me come and look after the house than a stranger. They gave me a present of money last time, but this time it'll be clothes for the boy. There's nothing to boys' clothes really. They don't mean anything.'

She sighed and looked around her.

'Well,' she said, 'we would like them to ask us over here more often than they do. Our town is way smaller than this, way smaller, but you can get all the same stuff there that you can here, if you've got the money to pay. I mean groceries and clothing and appliances. We've got all that. As soon as the walls are dry we go back. Franklin doesn't want to. He don't like his home because he lives in an apartment; it's in the business section. He sits in a lot and don't go out and contact at all.'

The light shone through Mary's tightly closed lids. In the chair next to her there was no sound of a body stirring. She opened her eyes and looked down. His ankles were crossed and his feet were absolutely still.

'Franklin,' the woman said, 'get some candy for me and the girl.'

When he had gone she turned to Mary. 'He's not a rough boy like the others,' she said. 'I don't know what I'd do if he was one of the real ones with all the trimmings. He's got some girl in him, thank the Lord. I couldn't handle one of the real ones.'

He came out of the freshly painted room carrying a box.

'We keep our candy in tea boxes. We have for years,' the

67

woman said. 'They're good conservers.' She shrugged her shoulders. 'What more can you expect? Such is life.' She turned to her son. 'Open it and pass it to the girl first. Then me.'

The orange box was decorated with seated women and temples. Mary recognised it; her mother used the same tea at home. He slipped off the two rubber bands that held the cover on, and offered her the open box. With stiff fingers she took a stick of green candy from the top; she did not raise her eyes.

A few minutes later she was running alone down the stone steps. It was almost night, but the sky was faintly green near the horizon. She crossed the highway and stood on the hill only a few feet away from the pit. Far below her, lights were twinkling in the Polish section. Down there the shacks were stacked one against the other in a narrow strip of land between the lower road and the river.

After gazing down at the sparkling lights for a while, she began to breathe more easily. She had never experienced the need to look at things from a distance before, nor had she felt the relief that it can bring. All at once, the air stirring around her head seemed delightful; she drank in great draughts of it, her eyes fixed on the lights below.

'This isn't the regular air from up here that I am breathing,' she said to herself. 'It's the air from down there. It's a trick I can do.'

She felt her blood tingle as it always did whenever she scored a victory, and she needed to score several of them in the course of each day. This time she was defeating the older woman.

The following afternoon, even though it was raining hard, her mother could not stop her from going out, but she had promised to keep her hood buttoned and not to sit on the ground.

The stone steps were running with water. She sat down and looked into the enveloping mist, a fierce light in her eyes. Her fingers twitched nervously, deep in the recess of her rubber pockets. It was unbelievable that they should not at any

On our Las Vegas Nevada

moment encounter something wonderful and new, unbelievable, too, that he should be ignorant of her love for him. Surely he knew that all the while his mother was talking, she in secret had been claiming him for her own. He would come out soon to join her on the steps, and they would go away together.

Hours later, stiff with cold, she stood up. Even had he remained all day at the window he could never have sighted her through the heavy mist. She knew this, but she could never climb the steps to fetch him; that was impossible. She ran headlong down the stone steps and across the highway. When she reached the pit she stopped dead and stood with her feet in the soft clay mud, panting for breath.

'Men,' she said after a minute, 'men, I told you we were going to specialise.' She stopped abruptly, but it was too late. She had, for the first time in her life, spoken to her men before summoning them to order with a bugle call. She was shocked, and her heart beat hard against her ribs, but she went on. 'We're going to be the only outfit in the world that can do real mountain-goat fighting.' She closed her eyes, seeking the dark gulf again; this time she needed to hear the men's hearts beating, more clearly than her own. A car was sounding its horn on the highway. She looked up.

'We can't climb those stone steps up there.' She was shouting and pointing at the house. 'No outfit can, no outfit ever will....' She was desperate. 'It's not for outfits. It's a flight of steps that's not for outfits... because it's... because....' The reason was not going to come to her. She had begun to cheat now, and she knew it would never come.

She turned her cold face away from the pit, and without dismissing her men, crept down the hill.

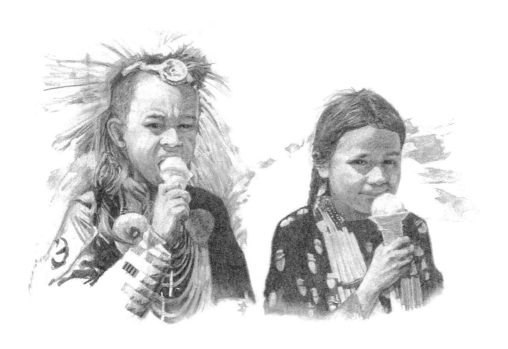

NARCISSUS BAY

One summer, when I was staying with my mother at Wei-hai-wei in China, I remember seeing four men and one woman coming down through the woods from the mountain. Two of the men had their hands tied behind their backs; their chests were naked, and they had thick ropes round their necks. The other two held these ropes, which they made to curl and ripple as they drove their prisoners on. The woman walked behind. Her dusty black hair was torn down over her face and shoulders. Blood oozed from cuts on her scalp; a patch of oiled paper had been stuck over one gash, and her lips were swollen and bruised. White cotton puffed out of the sharp tears all over her quilted clothes. She was crying and shaking her head exaggeratedly. In her hands she carried a thick stick broken in two. Where the bark had peeled off, I saw blood on the white, silky wood.

I stood dumbfounded, watching them pass out of the lemon-coloured light under the leaves into the biting sunshine. The woman as she passed me held out the broken stick in pantomime. She ran her cries together, making them into a sort of whining song. The two men holding the ropes jerked the necks of their victims, swore at them, spat on their yellow-brown backs. Then the little procession moved on down the rocky path to the town.

I watched until they disappeared round a bend. My fascinated eyes came back to the cool leafy place where I was, and I could hardly believe what I had seen. I pictured it all to myself again, and the story was unfolded. I saw the men beating the woman outside a thatched hut, close to a smouldering fire. She had exasperated them in some way and they both set on her. But her screams at last roused the village policemen, who came running to help her. They threw ropes round the necks of her attackers, and tied their hands behind their backs.

Now they were all going down to the courthouse in the town, where the woman would show the bloodstained stick

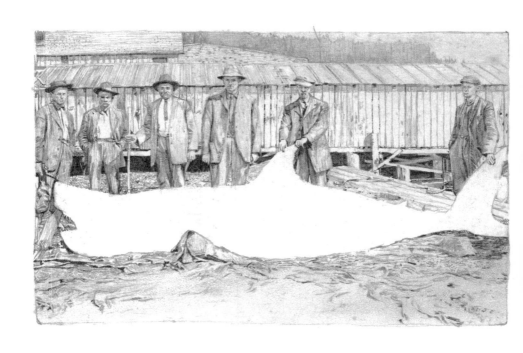

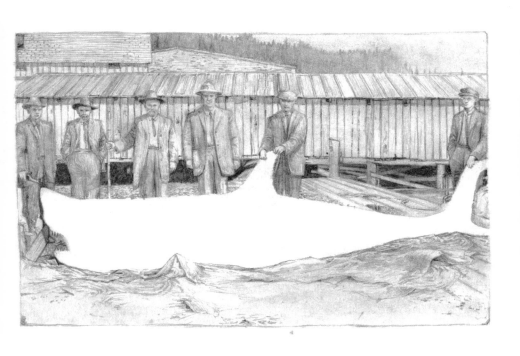

and tell her story. She was nursing her tears – just as I had done myself – because she wanted the judge to be sorry for her.

This all came very vividly to me. Perhaps the woman's expressive dumb-show had made it easy for me to reconstruct the whole story.

I thought again of the blood seen through her matted hair. It was the most barbarous sight I had yet seen and I held it to me with all the violence of new possession. I could not have rid my mind of it if I had tried.

Gradually the picture so overwhelmed me that I began to hate the glade where I had first seen the sight. I darted away, down towards the beach, and did not stop running till I felt the sand under my feet.

On the beach I found two girls I knew, playing outside their bamboo-matting bathing-hut. They were both older than I was; they had reddish down on their thick arms and legs, and their lips were full and well shaped. They treated their Belgian governess with the utmost harshness.

Now, as I approached, they called out and said that they had decided to eat nothing for the whole day. They would touch no meat, no sweet, no wheat, no beet; no fruit, no root; no nut, no gut –. They rhymed until they had nothing but nonsense words left; then, to fill a gap, I said, 'Where is your mademoiselle?'

'*Elle est grosse et grasse*,' chanted the elder girl, taking no notice of my question, pleased only to have an opportunity of abusing her governess. She repeated her sentence several times in a very loud voice and curved her hands in and out in imitation of the repulsive lines of mademoiselle's body.

I knew then that their governess was quite near, though hidden. I guessed that they had driven her into retreat behind some rock, where she was knitting. They would go on insulting her until they were tired of the game.

I wondered whether to tell the girls about my extraordinary experience or not. I really wanted to keep it to myself, but I had

the control. I wanted, too, to describe the horror to them and the unreal, magic atmosphere.

I began to tell them about the ropes, the wounds, the blood, and the broken stick. They listened contemptuously, sometimes throwing out their arms and legs, or twitching their nostrils in disbelief. But I knew that I had stirred them.

'What a liar!' the younger one said when I had finished. She said it mildly, as if she'd known me to be one for a long time.

'Which way did they go?' the other asked with heavy sarcasm; but her eyes were watching sharply.

'Towards the town,' I said. And immediately they were away, over the sand and the rough tufted grass. They were running down the white road and mademoiselle had risen up from behind her rock and was screaming to them to come back.

'Mary! Rosalie!' she cried, but they never turned their heads. Hopelessly she started to run after them. The town was forbidden and she did not know what she was going to say to their mother.

I watched her fatness jellying for a little; then I turned away and searched for fan shells along the beach. Once or twice I had found softest pink ones and ones of coral scarlet, but now I found nothing. I wondered whether to go home or to go on to the end of the bay and have tea with Adam Grant and his mother.

I decided to visit Adam. I was still restless. My thoughts were seething and my body tingled. I would arrive a little early and perhaps a little dirty, but I hoped Mrs Grant would not mind.

I walked slowly over the wet sand, close to the waves; but I soon reached the stone steps and the rock pools. I idled on the steps, leaning on the iron rail and staring into the depths of the pools from above. At last I climbed up to the terrace and found Adam lying there in a wicker chair. He looked up and told me importantly that he wasn't very well, he wasn't allowed to bathe, and his mother had pinned a flannel band round his stomach because she thought he had a chill there.

This struck me as ridiculous and rather disgusting in hot weather, and I said, 'But what good will that do?'

'Of course it's the thing to put on for a chill in your stomach,' Adam replied pompously; then he pretended to go on reading his book.

I stared at him. He was rather a fat boy with hair like coconut matting. I laughed to think of the flannel band round his stomach. Still he kept his eyes on his book; but I smiled, knowing that I could make him drop his show of indifference.

'Today I saw two men with ropes round their necks, and a woman who'd been beaten all over,' I said flatly, without any colour, to give my words their greatest effect.

Adam's head jerked up.

'Where? When did you see it?'

He seemed about to run out to look for the sight as the girls had done.

'Oh, it was a long time ago, up on the edge of the wood,' I said languidly.

Adam poured out questions and I answered them with maddening slowness and vagueness. The story filled him with excitement, but at the end he remembered to say, 'How awful for two men to beat a woman like that!'

He was still showing horror at the brutality, when his mother called out in a boisterous singsong voice, 'Tea's ready!' and we both got up to go into the cool shaded dining-room.

There we found Mrs Grant and another, younger boy, who, with his nurse, was also staying in the house. We sat down at the long narrow table and Mrs Grant began to pour out. While Adam passed the bread and butter, I watched her. She was a soldier's wife, and I had the idea that she was very superstitious. Perhaps I exaggerated, but I imagined that her religion was made up of patent medicines, charms and unmeaning rites – such as the pinning of the flannel round Adam's stomach. I felt sorry for her – she was so very benighted and unaware of real things.

The other boy was silent. He was nervous and puzzled because he believed nearly everything that was said to him.

I looked at the tea and saw that it was good: peanut butter, brown bread, chocolate biscuits, and sponge cake. At first I was pleased; then I began to feel out of sympathy with everyone, and I longed to get away and be alone.

We played in the garden after tea, hiding behind the huge hollyhocks, springing out at one another.

Adam told the younger boy to eat one of the dead flower heads, then to drink some slimy green water in an earthenware crock. He shouted at him, 'If you sit on the lavatory seat too long a swordfish will come up and bite you.'

I saw Derek's face jump. He really believed it, and the thought was going to frighten him forever.

Adam followed up his success with other horror stories.

'If you swim into a jellyfish and it stings your face, it'll blind you; and if a baby octopus gets hold of you it can suck the life out of you. A shark too can bite a leg off as easy as anything. Once they brought a man in with no arms or legs left.'

Derek put his arm across his mouth and bit the flesh. His eyes were terrified. He wanted someone to deny the stories, but I was too lazy and uninterested to do so, and his nurse was far away, gossiping to Mrs Grant on the veranda.

Adam made a lunge at him with a pole and when he flinched said, 'What's the matter? I was only pretending that I was harpooning a whale.'

To get away from us Derek ran into one of the bathrooms and locked the door. Adam climbed up to the window and made terrible faces through the glass; then he said, 'You won't sit on the seat, will you, because of that swordfish.'

At this Derek burst into tears and wailed so noisily that his nurse came and reprimanded us all, not sparing Derek. I could see his eyes still puzzled, terrified, longing to find protection somewhere. I turned away, ashamed for myself and ashamed for

him. His nurse began to undress him for bed. I heard the bath-water splashing.

Adam followed me out on to the rocks below the terrace. I disliked his stomach band, his fleshiness, his superstitious mother, and wished he would leave me. I wanted to be alone to watch the orange sun sink down into the sea.

To get away from him I moved from rock to rock until I was on a level with the pools. Still Adam followed me. I remembered that he was not supposed to bathe, and lying down on the edge of a pool I dipped my arm in and said, 'How lovely the water feels this evening!'

But you know I'm not allowed to bathe,' he said accusingly.

'Aren't you?' – and I rolled into the delicious water with my shirt and shorts and sandals on. I beat about with my hands and shouted out my delight.

Adam went stiff with envy and resentment, but I took no notice of his venomous remarks until I had played and splashed enough; then I climbed out and said, 'Lend me a lantern, I'm going home.'

It was not really dark enough for a lantern, but I wanted to carry a lighted one along the beach.

Adam grudgingly found me his and I lit the candle; then, after asking him to say goodbye to his mother for me, I set out along the ribbed sand.

The oiled cotton of the lantern was painted with large scarlet and black characters. I danced and jumped about, making the light bob up and down and throw shadows like ghosts. Showers of drops fell from my soaking clothes. Far out in the bay the phosphorus was beginning to fringe the wavelets.

The scene of the early afternoon came back to me with sudden violence. I saw again the woman and the four men winding down through the trees; and for some reason my thoughts jumped to the shrine which I knew was on the mountain above them. My mother and I had once climbed up to it and eaten

our picnic on the thymy grass in front. With my fingers I had picked out the little rock plants, like the flat round bottoms of artichokes.

The walls of the shrine were covered with peeling vermilion plaster and under the black curling roof were gods with little plates of food set before them, and joss-sticks, and gold and silver paper money scattered everywhere.

The clouds came down so low that they turned into veils of rainbow mist when the sun shone through them.

I thought of the utterly still, deserted place and I thought of the baked mud gods, all painted bright and gilded, gazing down, unmoving, caught in a trance, just watching everything, holding up their fingers, flashing their eyes and teeth forever.

CAMP
CATARACT

Beryl knocked on Harriet's cabin door and was given permission to enter. She found her friend seated near the window, an open letter in her hand.

'Good evening, Beryl,' said Harriet. 'I was just reading a letter from my sister.' Her fragile, spinsterish face wore a canny yet slightly hysterical expression.

Beryl, a stocky blond waitress with stubborn eyes, had developed a dogged attachment to Harriet and sat in her cabin whenever she had a moment to spare. She rarely spoke in Harriet's presence, nor was she an attentive listener.

'I'll read you what she says; have a seat.' Harriet indicated a straight chair and Beryl dragged it into a dark corner where she sat down. It creaked dangerously under the weight of her husky body.

'Hope I don't bust the chair,' said Beryl, and she blushed furiously, digging her hands deep into the pockets of the checked plus-fours she habitually wore when she was not on duty.

'"Dear Sister,"' Harriet read. '"You are still at Camp Cataract visiting the falls and enjoying them. I always want you to have a good time. This is your fifth week away. I suppose you go on standing behind the falls with much enjoyment like you told me all the guests did. I think you said only the people who don't stay overnight have to pay to stand behind the waterfall...

you stay ten weeks... have a nice time, dear. Here everything is exactly the same as when you left. The apartment doesn't change. I have something I want to tell you, but first let me say that if you get nervous, why don't you come home instead of waiting until you are no good for the train trip? Such a thing could happen. I wonder of course how you feel about the apartment once you are by the waterfall. Also, I want to put this to you. Knowing that you have an apartment and a loving family must make Camp Cataract quite a different place than it would be if it were all the home and loving you had. There must be wretches like that up there. If you see them, be sure to give them loving because they are the lost souls of the earth. I fear nomads. I am afraid of them and afraid for them too. I don't know what I would do if any of my dear ones were seized with the wanderlust. We are meant to cherish those who through God's will are given into our hands. First of all come the members of the family, and for this it is better to live as close as possible. Maybe you would say, 'Sadie is old-fashioned; she doesn't want people to live on their own.' I am not old-fashioned, but I don't want any of us to turn into nomads. You don't grow rich in spirit by widening your circle but by tending your own. When you are gone, I get afraid about you. I think that you might be seized with the wanderlust and that you are not remembering the apartment very much. Particularly this trip... but then I know this cannot be true and that only my nerves make me think such things. It's so hot out. This is a record-breaking summer. Remember, the apartment is not just a row of rooms. It is the material proof that our spirits are so wedded that we have but one blessed roof over our heads. There are only three of us in the apartment related by blood, but Bert Hoffer has joined the three through the normal channels of marriage, also sacred. I know that you feel this way too about it and that just nerves makes me think that Camp Cataract can change anything. May I remind you also that if this family is a garland, you are the middle

flower; for me you are anyway. Maybe Evy's love is now flowing more to Bert Hoffer because he's her husband, which is natural. I wish they didn't think you needed to go to Camp Cataract because of your spells. Haven't I always tended you when you had them? Bert's always taken Evy to the Hoffers and we've stayed together, just the two of us, with the door safely locked so you wouldn't in your excitement run to a neighbour's house at all hours of the morning. Evy liked going to the Hoffers because they always gave her chicken with dumplings or else goose with red cabbage. I hope you haven't got it in your head that just because you are an old maid you have to go somewhere and be by yourself. Remember, I am also an old maid. I must close now, but I am not satisfied with my letter because I have so much more to say. I know you love the apartment and feel the way I feel. You are simply getting a tourist's thrill out of being there in a cabin like all of us do. I count the days until your sweet return. Your loving sister, Sadie."'

Harriet folded the letter. 'Sister Sadie,' she said to Beryl, 'is a great lover of security.'

'She sounds swell,' said Beryl, as if Harriet were mentioning her for the first time, which was certainly not the case.

'I have no regard for it whatsoever,' Harriet announced in a positive voice. '*None.* In fact, I am a great admirer of the nomad, vagabonds, gypsies, seafaring men. I tip my hat to them; the old prophets roamed the world for that matter too, and most of the visionaries.' She folded her hands in her lap with an air of satisfaction. Then, clearing her throat as if for a public address, she continued. 'I don't give a tinker's damn about feeling part of a community, I can assure you.... That's not why I stay on at the apartment... not for a minute, but it's a good reason why she does... I mean Sadie; she loves a community spirit and she loves us all to be in the apartment because the apartment is in the community. She can get an actual thrill out of knowing that. But of course I can't... I never could, never in a thousand years.'

She tilted her head back and half-closed her eyes. In the true style of a person given to interminable monologues, she was barely conscious of her audience. 'Now,' she said, 'we can come to whether I, on the other hand, get a thrill out of Camp Cataract.' She paused for a moment as if to consider this. 'Actually, I don't,' she pronounced sententiously, 'but if you like, I will clarify my statement by calling Camp Cataract my *tree house*. You remember tree houses from your younger days.... You climb into them when you're a child and plan to run away from home once you are safely hidden among the leaves. They're popular with children. Suppose I tell you point-blank that I'm an extremely original woman, but also a very shallow one... in a sense, a *very* shallow one. I am afraid of scandal.' Harriet assumed a more erect position. 'I despise anything that smacks of a bohemian dash for freedom; I know that this has nothing to do with the more serious things in life... I'm sure there are hundreds of serious people who kick over their traces and jump into the gutter; but I'm too shallow for anything like that... I know it and I enjoy knowing it. Sadie on the other hand cooks and cleans all day long and yet takes her life as seriously as she would a religion... myself and the apartment and the Hoffers. By the Hoffers, I mean my sister Evy and her big pig of a husband Bert.' She made a wry face. 'I'm the only one with taste in the family but I've never even suggested a lamp for the apartment. I wouldn't lower myself by becoming involved. I do however refuse to make an unseemly dash for freedom. I refuse to be known as 'Sadie's wild sister Harriet.' There is something intensely repulsive to me about unmarried women setting out on their own... also a very shallow attitude. You may wonder how a woman can be shallow and know it at the same time, but then, this is precisely the tragedy of any person, if he allows himself to be gripped. She paused for a moment and looked into the darkness with a fierce light in her eyes. 'Now let's get back to Camp Cataract,' she said with renewed vigour. 'The pine groves,

the canoes, the sparkling purity of the brook water and cascade... the cabins... the marshmallows, the respectable clientele.'

'Did you ever think of working in a garage?' Beryl suddenly blurted out, and then she blushed again at the sound of her own voice.

'No,' Harriet answered sharply. 'Why should I?'

Beryl shifted her position in her chair. 'Well,' she said, 'I think I'd like that kind of work better than waiting on tables. Especially if I could be boss and own my garage. It's hard, though, for a woman.'

Harriet stared at her in silence. 'Do you think Camp Cataract smacks of the gutter?' she asked a minute later.

'No, sir....' Beryl shook her head with a woeful air.

'Well then, there you have it. It is, of course, the farthest point from the gutter that one could reach. Any blockhead can see that. My plan is extremely complicated and from my point of view rather brilliant. First I will come here for several years... I don't know yet exactly how many, but long enough to imitate roots... I mean to imitate the natural family roots of childhood... long enough so that I myself will feel: 'Camp Cataract is *habit*, Camp Cataract is life, Camp Cataract is not escape.' Escape is unladylike, habit isn't. As I remove myself gradually from within my family circle and establish myself more and more solidly into Camp Cataract, then from here at some later date I can start making my sallies into the outside world almost unnoticed. None of it will seem to the onlooker like an ugly impetuous escape. I intend to rent the same cabin every year and to stay a little longer each time. Meanwhile I'm learning a great deal about trees and flowers and bushes... I am interested in nature.' She was quiet for a moment. 'It's rather lucky too,' she added, 'that the doctor has approved of my separating from the family for several months out of every year. He's a blockhead and doesn't remotely suspect the extent of my scheme nor how perfectly he fits into it... in fact, he has even sanctioned my

95

request that no one visit me here at the camp. I'm afraid if Sadie did, and she's the only one who would dream of it, I wouldn't be able to avoid a wrangle and then I might have a fit. The fits are unpleasant; I get much more nervous than I usually am and there's a blank moment or two.' Harriet glanced sideways at Beryl to see how she was reacting to this last bit of information, but Beryl's face was impassive.

'So you see my plan,' she went on, in a relaxed, offhand manner, 'complicated, a bit dotty and completely original... but then, I *am* original... not like my sisters... oddly enough I don't even seem to belong socially to the same class as my sisters do. I am somehow' – she hesitated for a second – 'more fashionable.'

Harriet glanced out of the window. Night had fallen during the course of her monologue and she could see a light burning in the next cabin. 'Do you think I'm a coward?' she asked Beryl.

The waitress was startled out of her torpor. Fortunately her brain registered Harriet's question as well. 'No, sir,' she answered. 'If you were, you wouldn't go out paddling canoes solo, with all the scary shoots you run into up and down these rivers....'

Harriet twisted her body impatiently. She had a sudden and uncontrollable desire to be alone. 'Goodbye,' she said rudely. 'I'm not coming to supper.'

Beryl rose from her chair. 'I'll save something for you in case you get hungry after the dining room's closed. I'll be hanging around the lodge like I always am till bedtime.' Harriet nodded and the waitress stepped out of the cabin, shutting the door carefully behind her so that it would not make any noise.

Harriet's sister Sadie was a dark woman with loose features and sad eyes. She was turning slightly to fat in her middle years, and did not in any way resemble Harriet, who was only a few years her senior. Ever since she had written her last letter to Harriet about Camp Cataract and the nomads Sadie had suffered from a feeling of steadily mounting suspense – the suspense itself a curious mingling of apprehension and thrilling anticipation. Her appetite grew smaller each day and it was becoming increasingly difficult for her to accomplish her domestic tasks.

She was standing in the parlour gazing with blank eyes at her new furniture set – two enormous easy chairs with bulging arms and a sofa in the same style – when she said aloud: 'I can talk to her better than I can put it in a letter.' Her voice had been automatic and when she heard her own words a rush of un-bounded joy flooded her heart. Thus she realised that she was going on a little journey to Camp Cataract. She often made im-portant decisions this way, as if some prearranged plot were being suddenly revealed to her, a plot which had immediately to be concealed from the eyes of others, because for Sadie, if there was any problem implicit in making a decision, it lay, not in the difficulty of choosing, but in the concealment of her choice. To her, secrecy was the real absolution from guilt, so automatically she protected all of her deepest feelings and compulsions from the eyes of Evy, Bert Hoffer and the other members of the fam-ily, although she had no interest in understanding or examining these herself.

The floor shook; recognising Bert Hoffer's footsteps, she made a violent effort to control the flux of her blood so that the power of her emotion would not be reflected in her cheeks. A moment later her brother-in-law walked across the room and settled in one of the easy chairs. He sat frowning at her for quite a little while without uttering a word in greeting, but Sadie had long ago grown accustomed to his unfriendly

manner; even in the beginning it had not upset her too much because she was such an obsessive that she was not very concerned with outside details.

'God-damned velours,' he said finally. 'It's the hottest stuff I ever sat on.'

'Next summer we'll get covers,' Sadie reassured him, 'with a flower pattern if you like. What's your favourite flower?' she asked, just to make conversation and to distract him from looking at her face.

Bert Hoffer stared at her as if she'd quite taken leave of her senses. He was a fat man with a red face and wavy hair. Instead of answering this question, which he considered idiotic, he mopped his brow with his handkerchief.

'I'll fix you a canned pineapple salad for supper,' she said to him with glowing eyes. 'It will taste better than heavy meat on a night like this.'

'If you're going to dish up pineapple salad for supper,' Bert Hoffer answered with a dark scowl, 'you can telephone

some other guy to come and eat it. You'll find me over at Martie's Tavern eating meat and potatoes, if there's any messages to deliver.'

'I thought because you were hot,' said Sadie.

'I was talking about the velvet, wasn't I? I didn't say anything about the meat.'

He was a very trying man indeed, particularly in a small apartment, but Sadie never dwelled upon this fact at all. She was delighted to cook and clean for him and for her sister Evelyn so long as they consented to live under the same roof with her and Harriet.

Just then Evelyn walked briskly into the parlour. Like Sadie she was dark, but here the resemblance ceased, for she had a small and wiry build, with a flat chest, and her hair was as straight as an Indian's. She stared at her husband's shirt sleeves and at Sadie's apron with distaste. She was wearing a crisp summer dress with a very low neckline, an unfortunate selection for one as bony and fierce looking as she.

'You both look ready for the dump heap, not for the dining room,' she said to them. 'Why do we bother to have a dining room... is it just a farce?'

'How was the office today?' Sadie asked her sister.

Evelyn looked at Sadie and narrowed her eyes in closer scrutiny. The muscles in her face tightened. There was a moment of dead silence, and Bert Hoffer, cocking a wary eye in his wife's direction, recognised the dangerous flush on her cheeks. Secretly he was pleased. He loved to look on when Evelyn blew up at Sadie, but he tried to conceal his enjoyment because he did not consider it a very masculine one.

'What's the matter with you?' Evelyn asked finally, drawing closer to Sadie. 'There's something wrong besides your dirty apron.'

Sadie coloured slightly but said nothing.

'You look crazy,' Evelyn yelled. 'What's the matter with you? You look so crazy I'd be almost afraid to ask you to go to the store for something. Tell me what's happened!' Evelyn was very excitable; nonetheless hers was a strong and sane nature.

'I'm not crazy,' Sadie mumbled. 'I'll go get the dinner.' She pushed slowly past Evelyn and with her heavy step she left the parlour.

The mahogany dining table was much too wide for the small oblong-shaped room, clearing the walls comfortably only at the two ends. When many guests were present some were seated first on one side of the room and were then obliged to draw the table toward themselves, until its edge pressed painfully into their diaphragms, before the remaining guests could slide into their seats on the opposite side.

Sadie served the food, but only Bert Hoffer ate with any appetite. Evelyn jabbed at her meat once or twice, tasted it, and dropped her fork, which fell with a clatter on to her plate.

Had the food been more savoury she might not have pursued her attack on Sadie until later, or very likely she would have

forgotten it altogether. Unfortunately, however, Sadie, although she insisted on fulfilling the role of housewife, and never allowed the others to acquit themselves of even the smallest domestic task, was a poor cook and a careless cleaner as well. Her lumpy gravies were tasteless, and she had once or twice boiled a good cut of steak out of indifference. She was lavish, too, in spite of being indifferent, and kept her cupboards so loaded with food that a certain quantity spoiled each week and there was often an unpleasant odour about the house. Harriet, in fact, was totally unaware of Sadie's true nature and had fallen into the trap her sister had instinctively prepared for her, because beyond wearing an apron and simulating the airs of other housewives, Sadie did not possess a community spirit at all, as Harriet had stated to Beryl the waitress. Sadie certainly yearned to live in the grown-up world that her parents had established for them when they were children, but in spite of the fact that she had wanted to live in that world with Harriet, and because of Harriet, she did not understand it properly. It remained mysterious to her even though she did all the housekeeping and managed the apartment entirely alone. She couldn't ever admit to herself that she lived in constant fear that Harriet would go away, but she brooded a great deal on outside dangers, and had she tried, she could not have remembered a time when this fear had not been her strongest emotion.

Sometimes an ecstatic and voracious look would come into her eyes, as if she would devour her very existence because she loved it so much. Such passionate moments of appreciation were perhaps her only reward for living a life which she knew in her heart was one of perpetual narrow escape. Although Sadie was neither sly nor tricky, but on the contrary profoundly sincere and ingenuous, she schemed unconsciously to keep the Hoffers in the apartment with them, because she did not want to reveal the true singleness of her interest either to Harriet or to herself. She sensed as well that Harriet would find it more

difficult to break away from all three of them (because as a group they suggested a little society, which impressed her sister) than she would to escape from her alone. In spite of her mortal dread that Harriet might strike out on her own, she had never brooded on the possibility of her sister's marrying. Here, too, her instinct was correct: she knew that she was safe and referred often to the 'normal channels of marriage,' conscious all the while that such an intimate relationship with a man would be as uninteresting to Harriet as it would to herself.

From a financial point of view this communal living worked out more than satisfactorily. Each sister had inherited some real estate which yielded her a small monthly stipend; these stipends, combined with the extra money that the Hoffers contributed out of their salaries, covered their common living expenses. In return for the extra sum the Hoffers gave toward the household expenses, Sadie contributed her work, thus saving them the money they would have spent hiring a servant, had they lived alone. A fourth sister, whose marriage had proved financially more successful than Evy's, contributed generously toward Harriet's support at Camp Cataract, since Harriet's stipend certainly did not yield enough to cover her share of their living expenses at the apartment and pay for a long vacation as well.

Neither Sadie nor Bert Hoffer had looked up when Evy's fork clattered onto her plate. Sadie was truly absorbed in her own thoughts, whereas Bert Hoffer was merely pretending to be, while secretly he rejoiced at the unmistakeable signal that his wife was about to blow up.

'When I find out why Sadie looks like that if she isn't going to be crazy, then I'll eat,' Evelyn announced flatly, and she folded her arms across her chest.

'I'm not crazy,' Sadie said indistinctly, glancing toward Bert Hoffer, not in order to enlist his sympathies, but to avoid her younger sister's sharp scrutiny.

'There's a big danger of your going crazy because of Grandma and Harriet,' said Evelyn crossly. 'That's why I get so nervous the minute you look a little out of the way, like you do tonight. It's not that you get Harriet's expression... but then you might be getting a different kind of craziness... maybe worse. She's all right if she can go away and there's not too much excitement... it's only in spells anyway. But you – you might get a worse kind. Maybe it would be steadier.'

'I'm not going to be crazy,' Sadie murmured apologetically.

Evelyn glowered in silence and picked up her fork, but then immediately she let it fall again and turned on her sister with renewed exasperation. 'Why don't you ask me why *I'm* not going to be crazy?' she demanded. 'Harriet's my sister and Grandma's my grandma just as much as she is yours, isn't she?'

Sadie's eyes had a faraway look.

'If you were normal,' Evelyn pursued, 'you'd give me an intelligent argument instead of not paying any attention. Do you agree, Hoffer?'

'Yes, I do,' he answered soberly.

Evelyn stiffened her back. 'I'm too much like everybody else to be crazy,' she announced with pride. 'At a picture show, I feel like the norm.'

The technical difficulty of disappearing without announcing her plan to Evelyn suddenly occurred to Sadie, who glanced up quite by accident at her sister. She knew, of course, that Harriet was supposed to avoid contact with her family during these vacation months at the doctor's request and even at Harriet's own; but like some herd animal, who though threatened with the stick continues grazing, Sadie pursued her thought imperturbably. She did not really believe in Harriet's craziness nor in the necessity of her visits to Camp Cataract, but she was never in conscious opposition to the opinions of her sisters. Her attitude was rather like that of a child who is bored by the tedium of grown-up problems and listens to them with a vacant ear.

As usual she was passionately concerned only with successfully dissimulating what she really felt, and had she been forced to admit openly that there existed such a remarkable split between her own opinions and those of her sisters, she would have suffered unbelievable torment. She was able to live among them, listening to their conferences with her dead outside ear (the more affluent sister was also present at these sessions, and her husband as well), and even to contribute a pittance toward Harriet's support at the camp, without questioning the validity either of their decisions or of her own totally divergent attitude. By a self-imposed taboo, awareness of this split was denied her, and she had never reflected upon it.

Harriet had gone to Camp Cataract for the first time a year ago, after a bad attack of nerves combined with a return of her pleurisy. It had been suggested by the doctor himself that she go with his own wife and child instead of travelling with one of her sisters. Harriet had been delighted with the suggestion and Sadie had accepted it without a murmur. It was never her habit to argue, and in fact she had thought nothing of Harriet's leaving at the time. It was only gradually that she had begun writing the letters to Harriet about Camp Cataract, the nomads and the wanderlust – for she had written others similar to her latest one, but never so eloquent or full of conviction. Previous letters had contained a hint or two here and there, but had been for the main part factual reports about her summer life in the apartment. Since writing this last letter she had not been able to forget her own wonderful and solemn words (for she was rarely eloquent), and even now at the dinner table they rose continually in her throat so that she was thrilled over and over again and could not bother her head about announcing her departure to Evelyn. 'It will be easier to write a note,' she said to herself. 'I'll pack my valise and walk out tomorrow afternoon, while they're at business. They can get their own dinners for a few days. Maybe I'll leave a great big meatloaf.' Her eyes were shining like stars.

'Take my plate and put it in the warmer, Hoffer,' Evelyn was saying. 'I won't eat another mouthful until Sadie tells us what we can expect. If she feels she's going off, she can at least warn us about it. I deserve to know how she feels... I tell every single thing I feel to her and Harriet... I don't sneak around the house like a thief. In the first place I don't have any time for sneaking, I'm at the office all day! Is this the latest vogue, this sneaking around and hiding everything you can from your sister? Is it?' She stared at Bert Hoffer, widening her eyes in fake astonishment. He shrugged his shoulders.

'I'm no sneak or hypocrite and neither are you, Hoffer, you're no hypocrite. You're just sore at the world, but you don't pretend you love the world, do you?'

Sadie was lightheaded with embarrassment. She had blanched at Evy's allusion to her going, which she mistook naturally for a reference to her intention of leaving for Camp Cataract.

'Only for a few days...' she mumbled in confusion, 'and then I'll be right back here at the table.'

Evelyn looked at her in consternation. 'What do you mean by announcing calmly how many days it's going to be?' she shouted at her sister. 'That's really sacrilegious! Did you ever hear of such a crusty sacrilegious remark in your life before?' She turned to Bert Hoffer, with a horror-stricken expression on her face. 'How can I go to the office and look neat and clean and happy when this is what I hear at home... when my sister sits here and says she'll only go crazy for a few days? How *can* I go to the office after that? How can I look right?'

'I'm not going to be crazy,' Sadie assured her again in a sorrowful tone, because although she felt relieved that Evelyn had not, after all, guessed the truth, hers was not a nature to indulge itself in trivial glee at having put someone off her track.

'You just said you were going to be crazy,' Evelyn exclaimed heatedly. 'Didn't she, Bert?'

'Yes,' he answered, 'she did say something like that...'

The tendons of Evelyn's neck were stretched tight as she darted her eyes from her sister's face to her husband's. 'Now, tell me this much,' she demanded, 'do I go to the office every day looking neat and clean or do I go looking like a bum?'

'You look O.K.,' Bert said.

'Then why do my sisters spit in my eye? Why do they hide everything from me if I'm so decent? I'm wide open, I'm frank, there's nothing on my mind besides what I say. Why can't they be like other sisters all over the world? One of them is so crazy that she must live in a cabin for her nerves at *my* expense, and the other one is planning to go crazy deliberately and behind my back.' She commenced to struggle out of her chair, which as usual proved to be a slow and laborious task. Exasperated, she shoved the table vehemently away from her toward the opposite wall. 'Why don't we leave the space all on one side when there's no company?' she screamed at both of them, for she was now annoyed with Bert Hoffer as well as with Sadie. Fortunately they were seated at either end of the table and so did not suffer as a result of her violent gesture, but the table jammed into four chairs ranged on the opposite side, pinning three of them backward against the wall and knocking the fourth onto the floor.

'Leave it there,' Evelyn shouted dramatically above the racket. 'Leave it there till doomsday,' and she rushed headlong out of the room.

They listened to her gallop down the hall.

'What about the dessert?' Bert Hoffer asked Sadie with a frown. He was displeased because Evelyn had spoken to him sharply.

'Leftover bread pudding without raisins.' She had just gotten up to fetch the pudding when Evelyn summoned them from the parlour.

'Come in here, both of you,' she hollered. 'I have something to say.'

108

They found Evelyn seated on the couch, her head tilted way back on a cushion, staring fixedly at the ceiling. They settled into easy chairs opposite her.

'I could be normal and light in any other family,' she said, 'I'm normally a gay light girl... not a morose one. I like all the material things.'

'What do you want to do tonight?' Bert Hoffer interrupted, speaking with authority. 'Do you want to be excited or do you want to go to the movies?' He was always bored by these self-appraising monologues which succeeded her explosions.

Evy looked as though she had not heard him, but after a moment or two of sitting with her eyes shut she got up and walked briskly out of the room; her husband followed her.

Neither of them had said goodbye to Sadie, who went over to the window as soon as they'd gone and looked down on the huge unsightly square below her. It was crisscrossed by trolley tracks going in every possible direction. Five pharmacies and seven cigar stores were visible from where she stood. She knew that modern industrial cities were considered ugly, but she liked them. 'I'm glad Evy and Bert have gone to a picture show,' Sadie remarked to herself after a while. 'Evy gets high-strung from being at the office all day.'

A little later she turned her back on the window and went to the dining room.

'Looks like the train went through here,' she murmured, gazing quietly at the chairs tilted back against the wall and the table's unsightly angle; but the tumult in her breast had not subsided, even though she knew she was leaving for Camp Cataract. Beyond the first rush of joy she had experienced when her plan had revealed itself to her earlier, in the parlour, the feeling of suspense remained identical, a curious admixture of anxiety and anticipation, difficult to bear. Concerning the mechanics of the trip itself she was neither nervous nor foolishly excited. 'I'll call up tomorrow,' she said to herself, 'and find out

when the buses go, or maybe I'll take the train. In the morning I'll buy three different meats for the loaf, if I don't forget. It won't go rotten for a few days, and even if it does they can eat at Martie's or else Evy will make bologna and eggs... she knows how, and so does Bert.' She was not really concentrating on these latter projects any more than she usually did on domestic details.

The lamp over the table was suspended on a heavy iron chain. She reached for the beaded string to extinguish the light. When she released it the massive lamp swung from side to side in the darkness.

'Would you like it so much by the waterfall if you didn't know the apartment was here?' she whispered into the dark, and she was thrilled again by the beauty of her own words. 'How much more I'll be able to say when I'm sitting right next to her,' she murmured almost with reverence. '...And then we'll come back here,' she added simply, not in the least startled to discover that the idea of returning with Harriet had been at the root of her plan all along.

Without bothering to clear the plates from the table, she went into the kitchen and extinguished the light there. She was suddenly overcome with fatigue.

When Sadie arrived at Camp Cataract it was raining hard.

'This shingled building is the main lodge,' the hack driver said to her. 'The ceiling in there is three times higher than average, if you like that style. Go up on the porch and just walk in. You'll get a kick out of it.'

Sadie reached into her pocketbook for some money.

'My wife and I come here to drink beer when we're in the mood,' he continued, getting out his change. 'If there's nobody much inside, don't get panicky; the whole camp goes to the movies on Thursday nights. The wagon takes them and brings them back. They'll be along soon.'

After thanking him she got out of the cab and climbed the wooden steps on to the porch. Without hesitating she opened the door. The driver had not exaggerated; the room was indeed so enormous that it suggested a gymnasium. Wicker chairs and settees were scattered from one end of the floor to the other and numberless sawed-off tree stumps had been set down to serve as little tables.

Sadie glanced around her and then headed automatically for a giant fireplace, difficult to reach because of the accumulation of chairs and settees that surrounded it. She threaded her way between these and stepped across the hearth into the cold vault of the chimney, high enough to shelter a person of average stature. The andirons, which reached to her waist, had been wrought in the shape of witches. She fingered their pointed iron hats. 'Novelties,' she murmured to herself without enthusiasm. 'They must have been especially made.' Then, peering out of the fireplace, she noticed for the first time that she was not alone. Some fifty feet away a fat woman sat reading by the light of an electric bulb.

'She doesn't even know I'm in the fireplace,' she said to herself. 'Because the rain's so loud, she probably didn't hear me come in.' She waited patiently for a while and then, suspecting that the woman might remain oblivious to her presence

indefinitely, she called over to her. 'Do you have anything to do with managing Camp Cataract?' she asked, speaking loudly so that she could be heard above the rain.

The woman ceased reading and switched her big light off at once, since the strong glare prevented her seeing beyond the radius of the bulb.

'No, I don't,' she answered in a booming voice. 'Why?'

Sadie, finding no answer to this question, remained silent.

'Do you think I look like a manager?' the woman pursued, and since Sadie had obviously no intention of answering, she continued the conversation by herself.

'I suppose you might think I was manager here, because I'm stout, and stout people have that look; also I'm about the right age for it. But I'm not the manager... I don't manage anything, anywhere. I have a domineering cranium all right, but I'm more the French type. I'd rather enjoy myself than give orders.'

'French...' Sadie repeated hesitantly.

'Not French,' the woman corrected her. 'French *type*, with a little of the actual blood.' Her voice was cold and severe.

For a while neither of them spoke, and Sadie hoped the conversation had drawn to a definite close.

'Individuality is my god,' the woman announced abruptly, much to Sadie's disappointment. 'That's partly why I didn't go to the picture show tonight. I don't like doing what the groups do, and I've seen the film.' She dragged her chair forward so as to be heard more clearly. 'The steadies here – we call the ones who stay more than a fortnight steadies – are all crazy to get into birds-of-a-feather-flock-together arrangements. If you look around, you can see for yourself how clubby the furniture is fixed. Well, they can go in for it, if they want, but I won't. I keep my chair out in the open here, and when I feel like it I take myself over to one circle or another... there's about ten or twelve circles. Don't you object to the confinement of a group?'

'We haven't got a group back home,' Sadie answered briefly.

'I don't go in for group worship either,' the woman continued, 'any more than I do for the heavy social mixing. I don't even go in for individual worship, for that matter. Most likely I was born to such a vigorous happy nature I don't feel the need to worry about what's up there over my head. I get the full flavour out of all my days whether anyone's up there or not. The groups don't allow for that kind of zip... never. You know what rotten apples in a barrel can do to the healthy ones.'

Sadie, who had never before met an agnostic, was profoundly shocked by the woman's blasphemous attitude. 'I'll bet she slept with a lot of men she wasn't married to when she was younger,' she said to herself.

'Most of the humanity you bump into is unhealthy and nervous,' the woman concluded, looking at Sadie with a cold eye, and then without further remarks she struggled out of her chair and began to walk toward a side door at the other end of the room. Just as she approached it the door was flung open from the other side by Beryl, whom the woman immediately warned of the new arrival. Beryl, without ceasing to spoon some beans out of a can she was holding, walked over to Sadie and offered to be of some assistance. 'I can show you rooms,' she suggested. 'Unless you'd rather wait till the manager comes back from the movies.'

When she realised, however, after a short conversation with Sadie, that she was speaking to Harriet's sister, a malevolent scowl darkened her countenance, and she spooned her beans more slowly.

'Harriet didn't tell me you were coming,' she said at length; her tone was unmistakably disagreeable.

Sadie's heart commenced to beat very fast as she in turn realised that this woman in plus-fours was the waitress, Beryl, of whom Harriet had often spoken in her letters and at home.

'It's a surprise,' Sadie told her. 'I meant to come here before. I've been promising Harriet I'd visit her in camp for a long time

now, but I couldn't come until I got a neighbour in to cook for Evy and Bert. They're a husband and wife... my sister Evy and her husband Bert.'

'I know about those two,' Beryl remarked sullenly. 'Harriet's told me all about them.'

'Will you please take me to my sister's cabin?' Sadie asked, picking up her valise and stepping forward.

Beryl continued to stir her beans around without moving.

'I thought you folks had some kind of arrangement,' she said. She had recorded in her mind entire passages of Harriet's monologues out of love for her friend, although she felt no curiosity concerning the material she had gathered. 'I thought

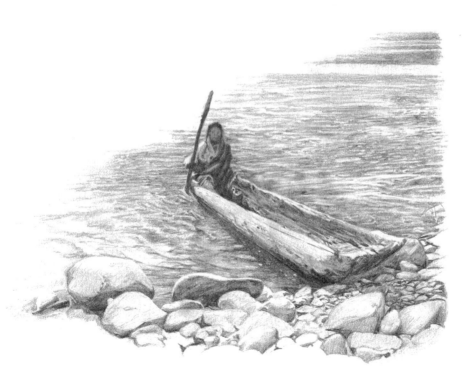

you folks were supposed to stay in the apartment while she was away at camp.'

'Bert Hoffer and Evy have never visited Camp Cataract,' Sadie answered in a tone that was innocent of any subterfuge.

'You bet they haven't,' Beryl pronounced triumphantly. 'That's part of the arrangement. They're supposed to say in the apartment while she's here at camp; the doctor said so.'

'They're not coming up,' Sadie repeated, and she still wore, not the foxy look that Beryl expected would betray itself at any moment, but the look of a person who is attentive though being addressed in a foreign language. The waitress sensed that all her attempts at starting a scrap had been successfully blocked for the present and she whistled carefully, dragging some chairs into line with a rough hand. 'I'll tell you what,' she said, ceasing her activities as suddenly as she has begun them. 'Instead of taking you down there to the Pine Cones – that's the name of the grove where her cabin is – I'll go myself and tell her to come up here to the lodge. She's got some nifty rain equipment so she won't get wet coming through the groves like you would... lots of pine trees out there.'

Sadie nodded in silence and walked over to a fantasy chair, where she sat down.

'They get a lot of fun out of that chair. When they're drunk,' said Beryl pointing to its back, made of a giant straw disc. 'Well... so long...' She strode away. 'Dear Valley...' Sadie heard her sing as she went out the door.

Sadie lifted the top of the chair's left arm and pulled two books out of its woven hamper. The larger volume was entitled *The Growth and Development of the Texas Oil Companies,* and the smaller, *Stories from Other Climes.* Hastily she replaced them and closed the lid.

Harriet opened the door for Beryl and quickly shut it again, but even in that instant the wooden flooring of the threshold was thoroughly soaked with rain. She was wearing a lavender kimono with a deep ruffle at the neckline; above it her face shone pale with dismay at Beryl's late and unexpected visit. She feared that perhaps the waitress was drunk. 'I'm certainly not hacking out a free place for myself in this world just in order to cope with drunks,' she said to herself with better verve. Her loose hair was hanging to her shoulders and Beryl looked at it for a moment in mute admiration before making her announcement.

'Your sister Sadie's up at the lodge,' she said, recovering herself; then, feeling embarrassed, she shuffled over to her usual seat in the darkest corner of the room.

'What are you saying?' Harriet questioned her sharply.

'Your sister Sadie's up at the lodge,' she repeated, not daring to look at her. 'Your sister Sadie who wrote you the letter about the apartment.'

'But she can't be!' Harriet screeched. 'She can't be! It was all arranged that no one was to visit me here.'

'That's what I told her,' Beryl put in.

Harriet began pacing up and down the floor. Her pupils were dilated and she looked as if she were about to lose all control of herself. Abruptly she flopped down on the edge of the bed and began gulping in great draughts of air. She was actually practicing a system which she believed had often saved her from complete hysteria, but Beryl, who knew nothing about her method,

was horrified and utterly bewildered. 'Take it easy,' she implored Harriet. 'Take it easy!'

'Dash some water in my face,' said Harriet in a strange voice, but horror and astonishment anchored Beryl securely to her chair, so that Harriet was forced to stagger over to the basin and manage by herself. After five minutes of steady dousing she wiped her face and chest with a towel and resumed her pacing. At each instant the expression on her face was more indignant and a trifle less distraught. 'It's the boorishness of it that I find so appalling,' she complained, a suggestion of theatricality in her tone which a moment before had not been present. 'If she's determined to wreck my schemes, why doesn't she do it with some style, a little slight bit of cunning? I can't picture anything more boorish than hauling oneself onto a train and simply chugging straight up here. She has no sense of scheming, of intrigue in the grand manner... none whatever. Anyone meeting only Sadie would think the family raised potatoes for a living. Evy doesn't make a much better impression, I must say. If they met her they'd decide we were all clerks! But at least she goes to business.... She doesn't sit around thinking about how to mess my life up all day. She thinks about Bert Hoffer. Ugh!' She made a wry face.

'When did you and Sadie start fighting?' Beryl asked her.

'I don't fight with Sadie,' Harriet answered, lifting her head proudly. 'I wouldn't dream of fighting like a common fishwife. Everything that goes on between us goes on undercover. It's always been that way. I've always hidden everything from her ever since I was a little girl. She's perfectly aware that I know she's trying to hold me a prisoner in the apartment out of plain jealousy and she knows too that I'm afraid of being considered a bum, and that makes matters simpler for her. She pretends to be worried that I might forget myself if I left the apartment and commit a folly with some man I wasn't married to, but actually she knows perfectly well that I'm as cold as ice. I haven't the

slightest interest in men... nor in women either for that matter; still if I stormed out of the apartment dramatically the way some do, they might think I was a bum on my way to a man... and I won't give Sadie that satisfaction, ever. As for marriage, of course I admit I'm peculiar and there's a bit wrong with me, but even so I shouldn't want to marry: I think the whole system of going through life with a partner is repulsive in every way.' She paused, but only for a second. 'Don't you imagine, however,' she added severely, looking directly at Beryl, 'don't you imagine that just because I'm a bit peculiar and different from the others, that I'm not fussy about my life. I *am* fussy about it, and I *hate* a scandal.'

'To hell with sisters!' Beryl exclaimed happily. 'Give 'em all a good swift kick in the pants.' She had regained her own composure watching the colour return to Harriet's cheeks and she was just beginning to think with pleasure that perhaps Sadie's arrival would serve to strengthen the bond of intimacy between herself and Harriet, when this latter buried her head in her lap and burst into tears. Beryl's face fell and she blushed at her own frivolousness.

'I can't any more,' Harriet sobbed in anguished tones. 'I can't... I'm old... I'm much too old.' Here she collapsed and sobbed so pitifully that Beryl, wringing her hands in grief, sprang to her side, for she was a most tenderhearted person toward those whom she loved. 'You are not old... you are beautiful,' she said, blushing again, and in her heart she was thankful that Providence had granted her the occasion to console her friend in a grief-stricken moment, and to compliment her at the same time.

After a bit, Harriet's sobbing subsided, and jumping up from the bed, she grabbed the waitress. 'Beryl,' she gasped, 'you must run back to the lodge right away.' There was a beam of cunning in her tear-filled eyes.

'Sure will,' Beryl answered.

'Go back to the lodge and see if there's a room left up there, and if there is, take her grip into it so that there will be no question of her staying in my cabin. I can't have her staying in my cabin. It's the only place I have in the whole wide world.' The beam of cunning disappeared again and she looked at Beryl with wide, frightened eyes. '…And if there's no room?' She asked.

'Then I'll put her in my place,' Beryl reassured her. 'I've got a neat little cabin all to myself that she can have and I'll go bunk in with some dopey waitress.'

'Well, then,' said Harriet, 'go, and hurry! Take her grip to a room in the upper lodge annex or to your own cabin before she has a chance to say anything, and then come straight back here for me. I can't get through these pine groves alone… now… I know I can't.' It did not occur to her to thank Beryl for the kind offer she had made.

'All right,' said the waitress, 'I'll be back in a jiffy and don't you worry about a thing.' A second later she was lumbering through the drenched pine groves with shining eyes.

When Beryl came into the lodge and snatched Sadie's grip up without a word of explanation, Sadie did not protest. Opposite her there was an open staircase which led to a narrow gallery hanging halfway between the ceiling and the floor. She watched the waitress climbing the stairs, but once she had passed the landing Sadie did not trouble to look up and follow her progress around the wooden balcony overhead.

A deep chill had settled into her bones, and she was like a person benumbed. Exactly when this present state had succeeded the earlier one Sadie could not tell, nor did she think to ask herself such a question, but a feeling of dread now lay like a stone in her breast where before there had been stirring such powerful sensations of excitement and suspense. 'I'm so low,' she said to herself. 'I feel like I was sitting at my own funeral.' She did not say this in the spirit of hyperbolic gloom which some people nurture to work themselves out of a bad mood, but in all seriousness and with her customary attitude of passivity; in fact, she wore the humble look so often visible on the faces of sufferers who are being treated in a free clinic. It did not occur to her that a connection might exist between her present dismal state and the mission she had come to fulfill at Camp Cataract, nor did she take any notice of the fact that the words which were to enchant Harriet and accomplish her return were no longer welling up in her throat as they had done all the past week. She feared that something dreadful might happen, but whatever it was, this disaster was as remotely connected with her as a possible train wreck. 'I hope nothing bad happens...' she thought, but she didn't have much hope in her.

Harriet slammed the front door and Sadie looked up. For the first second or two she did not recognise the woman who stood on the threshold in her dripping rubber coat and hood. Beryl was beside her; puddles were forming around the feet of the two women. Harriet had rouged her cheeks rather more highly than

usual in order to hide all traces of her crying spell. Her eyes were bright and she wore a smile that was fixed and hard.

'Not a night fit for man or beast,' she shouted across to Sadie, using a voice that she thought sounded hearty and yet fashionable at the same time; she did this, not in order to impress her sister, but to keep her at a safe distance.

Sadie, instead of rushing to the door, stared at her with an air of perplexity. To her Harriet appeared more robust and coarse-featured than she had five weeks ago at the apartment, and yet she knew that such a rapid change of physiognomy was scarcely possible. Recovering, she rose and went to embrace her sister. The embrace failed to reassure her because of Harriet's wet rubber coat, and her feeling of estrangement became more defined. She backed away.

Upon hearing her own voice ring out in such hearty and fashionable tones, Harriet had felt crazily confident that she might, by continuing to affect this manner, hold her sister at bay for the duration of her visit. To increase her chances of success she had determined right then not to ask Sadie why she had come, but to treat the visit in the most casual and natural way possible.

'Have you put on fat?' Sadie asked, at a loss for anything else to say.

'I'll never be fat,' Harriet replied quickly. 'I'm a fruit lover, not a lover of starches.'

'Yes, you love fruit,' Sadie said nervously. 'Do you want some? I have an apple left from my lunch.'

Harriet looked aghast. 'Now!' she exclaimed. 'Beryl can tell you that I never eat at night; in fact I never come up to the lodge at night, *never*. I stay in my cabin. I've written you all about how early I get up... I don't know anything about the lodge at night,' she added almost angrily, as though her sister had accused her of being festive.

'You don't?' Sadie looked at her stupidly.

'No, I don't. Are you hungry, by the way?'

'If she's hungry,' put in Beryl, 'we can go into the Grotto Room and I'll bring her the food there. The tables in the main dining room are all set up for tomorrow morning's breakfast.'

'I despise the Grotto,' said Harriet with surprising bitterness. Her voice was getting quite an edge to it, and although it still sounded fashionable, it was no longer hearty.

'I'm not hungry,' Sadie assured them both. 'I'm sleepy.'

'Well then,' Harriet replied quickly, jumping at the opportunity, 'we'll sit here for a few minutes and then you must go to bed.'

The three of them settled in wicker chairs close to the cold hearth. Sadie was seated opposite the other two, who both remained in their rubber coats.

'I really do despise the Grotto,' Harriet went on. 'Actually I don't hang around the lodge at all. This is not the part of Camp Cataract that interests me. I'm interested in the pine groves, my cabin, the rocks, the streams, the bridge, and all the surrounding natural beauty... the sky also.'

Although the rain still continued its drumming on the roof above them, to Sadie, Harriet's voice sounded intolerably loud, and she could not rid herself of the impression that her sister's face had grown fatter. 'Now,' she heard Harriet saying in her loud voice, 'tell me about the apartment... What's new, how are the dinners coming along, how are Evy and Bert?'

Fortunately, while Sadie was struggling to answer these questions, which unaccountably she found it difficult to do, the stout diagnostic reappeared, and Harriet was immediately distracted.

'Rover,' she called gaily across the room, 'come and sit with us. My sister Sadie's here.'

The woman joined them, seating herself beside Beryl, so that Sadie was now facing all three.

'It's a surprise to see you up at the lodge at night, Hermit,' she remarked to Harriet without a spark of mischief in her voice.

'You see!' Harriet nodded at Sadie with immense satisfaction. 'I was not fibbing, was I? How are Evy and Bert?' she asked again, her face twitching a bit. 'Is the apartment hot?'

Sadie nodded.

'I don't know how long you plan to stay,' Harriet rattled on, feeling increasingly powerful and therefore reckless, 'but I'm going on a canoe trip the day after tomorrow for five days. We're going up the river to Pocahontas Falls... I leave at four in the morning, too, which rather ruins tomorrow as well. I've been looking forward to this trip ever since last spring when I applied for my seat, back at the apartment. The canoes are limited, and the guides.... I'm devoted to canoe trips, as you know, and can fancy myself a red-skin all the way to the Falls and back, easily.'

Sadie did not answer.

'There's nothing weird about it,' Harriet argued. 'It's in keeping with my hatred of industrialisation. In any case, you can see what a chopped-up day tomorrow's going to be. I have to make my pack in the morning and I must be in bed by eight-thirty at night, the latest, so that I can get up at four. I'll have only one real meal, at two in the afternoon. I suggest we meet at two behind the souvenir booth; you'll notice it tomorrow.'

Harriet waited expectantly for Sadie to answer in agreement to this suggestion, but her sister remained silent.

'Speaking of the booth,' said Rover, 'I'm not taking home a single souvenir this year. They're expensive and they don't last.'

'You can buy salt-water taffy at Gerald's Store in town,' Beryl told her. 'I saw some there last week. It's a little stale but very cheap.'

'Why would they sell salt-water taffy in the mountains?' Rover asked irritably.

Sadie was half listening to the conversation; as she sat watching them, all three women were suddenly unrecognisable; it was

as if she had flung open the door to some dentist's office and seen three strangers seated there. She sprang to her feet in terror.

Harriet was horrified. 'What is it?' she yelled at her sister. 'Why do you look like that? Are you mad?'

Sadie was pale and beads of sweat were forming under her felt hat, but the women opposite her had already regained their correct relation to herself and the present moment. Her face relaxed, and although her legs were trembling as a result of her brief but shocking experience, she felt immensely relieved that it was all over.

'Why did you jump up?' Harriet screeched at her. 'Is it because you are at Camp Cataract and not at the apartment?'

'It must have been the long train trip and no food...' Sadie told herself, 'only one sandwich.'

'Is it because you are at Camp Cataract and not at the apartment?' Harriet insisted. She was really very frightened and wished to establish Sadie's fit as a purposeful one and not as an involuntary seizure similar to one of hers.

'It was a long and dirty train trip,' Sadie said in a weary voice. 'I had only one sandwich all day long, with no mustard or butter... just the processed meat. I didn't even eat my fruit.'

'Beryl offered to serve you food in the Grotto!' Harriet ranted. 'Do you want some now or not? For heaven's sake, speak up!'

'No... no.' Sadie shook her head sorrowfully. 'I think I'd best go to bed. Take me to your cabin... I've got my slippers and my kimono and my nightgown in my satchel,' she added, looking around her vaguely, for the fact that Beryl had carried her grip off had never really impressed itself upon her consciousness.

Harriet glanced at Beryl with an air of complicity and managed to give her a quick pinch. 'Beryl's got you fixed up in one of the upper lodge annex rooms,' she told Sadie in a false, chatterbox voice. 'You'll be much more comfortable up here than you would be down in my cabin. We all use oil lamps in the grove and you know how dependent you are on electricity.'

Sadie didn't know whether she was dependent on electricity or not since she had never really lived without it, but she was so tired that she said nothing.

'I get up terribly early and my cabin's draughty, besides,' Harriet went on. 'You'll be much more comfortable here. You'd hate the Boulder Dam wigwams as well. Anyway, the wigwams are really for boys and they're always full. There's a covered bridge leading from this building to the annex on the upper floor, so that's an advantage.'

'O.K., folks,' Beryl cut in, judging that she could best help Harriet by spurring them on to action. 'Let's get going.'

'Yes,' Harriet agreed, 'if we don't get out of the lodge soon the crowd will come back from the movies and we certainly want to avoid them.'

They bade good night to Rover and started up the stairs.

'This balustrade is made of young birch limbs,' Harriet told Sadie as they walked along the narrow gallery overhead. 'I think it's very much in keeping with the lodge, don't you?'

'Yes, I do,' Sadie answered.

Beryl opened the door leading from the balcony onto a covered bridge and stepped through it, motioning to the others. 'Here we go onto the bridge,' she said, looking over her shoulder. 'You've never visited the annex, have you?' she asked Harriet.

'I've never had any reason to,' Harriet answered in a huffy tone. 'You know how I feel about my cabin.'

They walked along the imperfectly fitted boards in the darkness. Gusts of wind blew about their ankles and they were constantly spattered with rain in spite of the wooden roofing. They reached the door at the other end very quickly, however, where they descended two steps leading into a short, brightly lit hall. Beryl closed the door to the bridge behind them. The smell of fresh plaster and cement thickened the damp air.

'This is the annex,' said Beryl. 'We put old ladies here mostly, because they can get back and forth to the dining room without

going outdoors... and they've got the toilet right here, too.' She flung open the door and showed it to them. 'Then also,' she added, 'we don't like the old ladies dealing with oil lamps and here they've got electricity.' She led them into a little room just at their left and switched on the light. 'Pretty smart, isn't it?' she remarked, looking around her with evident satisfaction, as if she herself had designed the room; then, sauntering over to a modernistic wardrobe-bureau combination, she polished a corner of it with her pocket handkerchief. This piece was made of shiny brown wood and fitted with a rimless circular mirror. 'Strong and good-looking,' Beryl said, rapping on the wood with her knuckles. 'Every room's got one.'

Sadie sank down on the edge of the bed without removing her outer garments. Here, too, the smell of plaster and cement permeated the air, and the wind still blew about their ankles, this time from under the badly constructed doorsill.

'The cabins are much draughtier than this,' Harriet assured Sadie once again. 'You'll be more comfortable here in the annex.' She felt confident that establishing her sister in the

powderdon't falls

annex would facilitate her plan, which was still to prevent her from saying whatever she had come to say.

Sadie was terribly tired. Her hat, dampened by the rain, pressed uncomfortably against her temples, but she did not attempt to remove it. 'I think I've got to go to sleep,' she muttered. 'I can't stay awake any more.'

'All right,' said Harriet, 'but don't forget tomorrow at two by the souvenir booth... you can't miss it. I don't want to see anyone in the morning because I can make my canoe pack better myself... it's frightfully complicated.... But if I hurried I could meet you at one-thirty; would you prefer that?'

Sadie nodded.

'Then I'll do my best.... You see, in the morning I always practice imagination for an hour or two. It does me lots of good, but tomorrow I'll cut it short.' She kissed Sadie lightly on the crown of her felt hat. 'Good night,' she said. 'Is there anything I forgot to ask you about the apartment?'

'No,' Sadie assured her. 'You asked everything.'

'Well, good night,' said Harriet once again, and followed by Beryl, she left the room.

When Sadie awakened the next morning a feeling of dread still rested like a leaden weight on her chest. No sooner had she left the room than panic, like a small wing, started to beat under her heart. She was inordinately fearful that if she strayed any distance from the main lodge she would lose her way and so arrive late for her meeting with Harriet. This fear drove her to stand next to the souvenir booth fully an hour ahead of time. Fortunately the booth, situated on a small knoll, commanded an excellent view of the cataract, which spilled down from some high rock ledges above a deep chasm. A fancy bridge spanned this chasm only a few feet below her, so that she was able to watch the people crossing it as they walked back and forth between the camp site and the waterfall. An Indian chief in full war regalia was seated at the bridge entrance on a kitchen chair. His magnificent feather headdress curved gracefully in the breeze as he busied himself collecting the small toll that all the tourists paid on returning from the waterfall; he supplied them with change from a nickel-plated conductor's belt which he wore over his deer-hide jacket, embroidered with minute beads. He was an Irishman employed by the management, which supplied his costume. Lately he had grown careless, and often neglected to stain his freckled hands the deep brick colour of his face. He divided his time between the bridge and the souvenir booth, clambering up the knoll whenever he sighted a customer.

A series of wooden arches, Gothic in conception, succeeded each other all the way across the bridge; bright banners fluttered from their rims, each one stamped with the initials of the camp, and some of them edged with a glossy fringe. Only a few feet away lay the dining terrace, a huge flagstone pavilion whose entire length skirted the chasm's edge.

Unfortunately, neither the holiday crowds, nor the festooned bridge, nor even the white waters of the cataract across the way could distract Sadie from her misery. She constantly glanced behind her at the dark pine groves wherein Harriet's

cabin was concealed. She dreaded to see Harriet's shape define itself between the trees, but at the same time she feared that if her sister did not arrive shortly some terrible catastrophe would befall them both before she'd had a chance to speak. In truth all desire to convince her sister that she should leave Camp Cataract and return to the apartment had miraculously shrivelled away, and with the desire, the words to express it had vanished too. This did not in any way alter her intention of accomplishing her mission; on the contrary, it seemed to her all the more desperately important now that she was almost certain, in her innermost heart, that her trip was already a failure. Her attitude was not an astonishing one, since like many others she conceived of her life as separate from herself; the road was laid out always a little ahead of her by sacred hands, and she walked down it without question. This road, which was her life, would go on existing after her death, even as her death existed now while she still lived.

There were close to a hundred people dining on the terrace, and the water's roar so falsified the clamor of voices that one minute the guests seemed to be speaking from a great distance and the next right at her elbow. Every now and then she thought she heard someone pronounce her name in a dismal tone, and however much she told herself that this was merely the waterfall playing its tricks on her ears she shuddered each time at the sound of her name. Her very position next to the booth began to embarrass her. She tucked her hands into her coat sleeves so that they would not show, and tried to keep her eyes fixed on the foaming waters across the way, but she had noticed a disapproving look in the eyes of the diners nearest her, and she could not resist glancing back at the terrace every few minutes in the hope that she had been mistaken. Each time, however, she was more convinced that she had read their expressions correctly, and that these people believed, not only that she was standing there for no good reason, but that she was a genuine vagrant who could

not afford the price of a dinner. She was therefore immensely relieved when she caught sight of Harriet advancing between the tables from the far end of the dining pavilion. As she drew nearer, Sadie noticed that she was wearing her black winter coat trimmed with red fur, and that her marceled hair remained neatly arranged in spite of the strong wind. Much to her relief Harriet had omitted to rouge her cheeks and her face therefore had regained its natural proportions. She saw Harriet wave at the sight of her and quicken her step. Sadie was pleased that the diners were to witness the impending meeting. 'When they see us together,' she thought, 'they'll realise that I'm no vagrant, but a decent woman visiting her sister.' She herself started down the knoll to hasten the meeting. 'I thought you'd come out of the pine grove,' she called out, as soon as they were within a few feet of one another. 'I kept looking that way.'

'I would have ordinarily,' Harriet answered, reaching her side and kissing her lightly on the cheek, 'but I went to the other end of the terrace first, to reserve a table for us from the waiter in charge there. That end is quieter, so it will be more suitable for a long talk.'

'Good,' thought Sadie as they climbed up the knoll together. 'Her night's sleep has done her a world of good.' She studied Harriet's face anxiously as they paused next to the souvenir booth, and discovered a sweet light reflected in her eyes. All at once she remembered their childhood together and the great tenderness Harriet had often shown towards her then.

'They have Turkish pilaff on the menu,' said Harriet, 'so I told the waiter to save some for you. It's such a favourite that it usually runs out at the very beginning. I know how much you love it.'

Sadie, realising that Harriet was actually eager for this dinner, the only one they would eat together at Camp Cataract, to be a success, felt the terrible leaden weight lifted from her heart; it disappeared so suddenly that for a moment or two she was like

COLD SPRING N.Y.

4 - 1941

COLD SPRING - N.Y.

4 - 1941

a balloon without its ballast; she could barely refrain from dancing about in delight. Harriet tugged on her arm.

'I think we'd better go now,' she urged Sadie, 'then after lunch we can come back here if you want to buy some souvenirs for Evy and Bert... and maybe for Flo and Carl and Bobby too....'

Sadie bent down to adjust her cotton stockings, which were wrinkling badly at the ankles, and when she straightened up again her eyes lighted on three men dining very near the edge of the terrace; she had not noticed them before. They were all eating corn on the cob and big round hamburger sandwiches in absolute silence. To protect their clothing from spattering kernels, they had converted their napkins into bibs.

'Bert Hoffer's careful of his clothes too,' Sadie reflected, and then she turned to her sister. 'Don't you think men look different sitting all by themselves without women?' she asked her. She felt an extraordinary urge to chat – an urge which she could not remember ever having experienced before.

'I think,' Harriet replied, as though she had not heard Sadie's comment, 'that we'd better go to our table before the waiter gives it to someone else.'

'I don't like men,' Sadie announced without venom, and she was about to follow Harriet when her attention was arrested by the eyes of the man nearest her. Slowly lowering his corn on the cob to his plate, he stared across at her, his mouth twisted into a bitter smile. She stood as if rooted to the ground, and under his steady gaze all her newborn joy rapidly drained away. With desperation she realised that Harriet, darting in and out between the crowded tables, would soon be out of sight. After making what seemed to her a superhuman effort she tore herself away from the spot where she stood and lunged after Harriet shouting her name.

Harriet was at her side again almost instantly, looking up at her with a startled expression. Together they turned to the sou-

venir booth, where Sadie stopped and assumed a slightly bent position as if she were suffering from an abdominal pain.

'What's the trouble?' she heard Harriet asking with concern. 'Are you feeling ill?'

Instead of answering Sadie laid her hand heavily on her sister's arm and stared at her with a hunted expression in her eyes.

'Please try not to look so much like a gorilla,' said Harriet in a kind voice, but Sadie, although she recognised the accuracy of this observation (for she could feel very well that she was looking like a gorilla), was powerless to change her expression, at least for a moment or two. 'Come with me,' she said finally, grabbing Harriet's hand and pulling her along with almost brutal force. 'I've got something to tell you.'

She headed down a narrow path leading into a thickly planted section of the grove, where she thought they were less likely to be disturbed. Harriet followed with such a quick, light step that Sadie felt no pull behind her at all and her sister's hand, folded in her own thick palm, seemed as delicate as the body of a bird. Finally they entered a small clearing where they stopped. Harriet untied a handkerchief from around her neck and mopped her brow. 'Gracious!' she said. 'It's frightfully hot in here.' She offered the kerchief to Sadie, 'I suppose it's because we walked so fast and because the pine trees shut out all the wind.... First I'll sit down and then you must tell me what's wrong.' She stepped over to a felled tree whose length blocked the clearing. Its torn roots were shockingly exposed, whereas the upper trunk and branches lay hidden in the surrounding grove. Harriet sat down; Sadie was about to sit next to her when she noticed a dense swarm of flies near the roots. Automatically she stepped toward them. 'Why are they here?' she asked herself – then immediately she spotted the cause, an open can of beans some careless person had deposited inside a small hollow at the base of the trunk. She turned away in disgust and looked back at Harriet. Her sister was seated on the fallen tree, her back grace-

fully erect and her head tilted in a listening attitude. The filtered light imparted to her face an incredibly fragile and youthful look, and Sadie gazed at her with tenderness and wonder. No sound reached them in the clearing, and she realised with a pounding heart that she could no longer postpone telling Harriet why she had come. She could not have wished for a moment more favourable to the accomplishment of her purpose. The stillness in the air, their isolation, the expectant and gentle light in Harriet's eye, all these elements should have combined to give her back her faith – faith in her own powers to persuade Harriet to come home with her and live among them once again, winter and summer alike, as she had always done before. She opened her mouth to speak and doubled over, clutching at her stomach as though an animal were devouring her. Sweat beaded her forehead and she planted her feet wide apart on the ground as if this animal would be born. Though her vision was barred with pain, she saw Harriet's tear-filled eyes, searching hers.

'Let's not go back to the apartment,' Sadie said, hearing her own words as if they issued not from her mouth but from a pit in the ground. 'Let's not go back there... let's you and me go out in the world... just the two of us.' A second before covering her face to hide her shame Sadie glimpsed Harriet's eyes, impossibly close to her own, their pupils pointed with a hatred such as she had never seen before.

It seemed to Sadie that it was taking an eternity for her sister to leave. 'Go away... go away... or I'll suffocate.' She was moaning the words over and over again, her face buried deep in her hands. 'Go away... please go away... I'll suffocate...' She could not tell, however, whether she was thinking these words or speaking them aloud.

At last she heard Harriet's footstep on the dry branches, as she started out of the clearing. Sadie listened, but although one step followed another, the cracking sound of the dry branches

did not grow any fainter as Harriet penetrated farther into the grove. Sadie knew that this agony she was suffering was itself the dreaded voyage into the world – the very voyage she had always feared Harriet would make. That she herself was making it instead of Harriet did not affect her certainty that this was it.

Sadie stood at the souvenir booth looking at some birchbark canoes. The wind was blowing colder and stronger than it had a while ago, or perhaps it only seemed this way to her, so recently returned from the airless clearing. She did not recall her trip back through the grove; she was conscious only of her haste to buy some souvenirs and to leave. Some chains of paper tacked to the side of the booth as decoration kept flying in her face. The Indian chief was smiling at her from behind the counter of souvenirs.

'What can I do for you?' he asked.

'I'm leaving,' said Sadie, 'so I want souvenirs....'

'Take your choice; you've got birchbark canoes with or without mailing cards attached, Mexican sombrero ashtrays, exhilarating therapeutic pine cushions filled with the regional needles... and banners for a boy's room.'

'There's no boy home,' Sadie said, having caught only these last words.

'How about cushions... or canoes?'

She nodded.

'Which do you want?'

'Both,' she answered quickly.

'How many?'

Sadie closed her eyes. Try as she would she could not count up the members of the family. She could not even reach an approximate figure. 'Eleven,' she blurted out finally, in desperation.

'Eleven of each?' he asked raising his eyebrows.

'Yes... yes,' she answered quickly, batting the paper chains out of her face, 'eleven of each.'

'You sure don't forget the old folks at home, do you?' he said, beginning to collect all the canoes. He made an individual package of each souvenir and then wrapped them all together in coarse brown paper which he bound with thick twine.

Sadie had given him a note and he was punching his money belt for the correct change when her eyes fell on his light, freck-

led hand. Startled, she shifted her glance from his hand punching the nickel belt to his brick-coloured face streaked with purple and vermilion paint. For the first time she noticed his Irish blue eyes. Slowly the hot flush of shame crept along the nape of her neck. It was the same unbearable mortification that she had experienced in the clearing; it spread upward from her neck to the roots of her hair, colouring her face a dark red. That she was ashamed for the Indian this time, and not of her own words, failed to lessen the intensity of her suffering; the boundaries of her pride had never been firmly fixed inside herself. She stared intently at his Irish blue eyes, so oddly light in his brick-coloured face. What was it? She was tormented by the sight of an incongruity she couldn't name. All at once she remembered the pavilion and the people dining there; her heart started to pound. 'They'll see it,' she said to herself in a panic. 'They'll see it and they'll know that I've seen it too.' Somehow this latter possibility was the most perilous of all.

'They must never know I've seen it,' she said, grinding her teeth, and she leaned over the counter, crushing some canoes under her chest. 'Quickly,' she whispered. 'Go out your little door and meet me back of the booth...'

A second later she found him there. 'Listen!' She clutched his hand. 'We must hurry... I didn't mean to see you... I'm sorry... I've been trying not to look at you for years... for years and years and years....' She gaped at him in horror. 'Why are you standing there? We've got to hurry... They haven't caught me looking at you yet, but we've got to hurry.' She headed for the bridge, leading the Indian behind her. He followed quickly without saying a word.

The water's roar increased in volume as they approached the opposite bank of the chasm, and Sadie found relief in the sound. Once off the bridge she ran as fast as she could along the path leading to the waterfall. The Indian followed close on her heels, his hand resting lightly in her own, as Harriet's had

earlier when they'd sped together through the grove. Reaching the waterfall, she edged along the wall of rock until she stood directly behind the water's cascade. With a cry of delight she leaned back in the curve of the wall, insensible to its icy dampness, which penetrated through the thickness of her woollen coat. She listened to the cataract's deafening roar and her heart almost burst for joy, because she had hidden the Indian safely behind the cascade where he could be neither seen nor heard. She turned around and smiled at him kindly. He too smiled, and she no longer saw in his face any trace of the incongruity that had shocked her so before.

The foaming waters were beautiful to see. Sadie stepped forward, holding her hand out to the Indian.

When Harriet awakened that morning all traces of her earlier victorious mood had vanished. She felt certain that disaster would overtake her before she could start out for Pocahontas Falls. Heavyhearted and with fumbling hands, she set about making her pack. Luncheon with Sadie was an impossible cliff which she did not have the necessary strength to scale. When she came to three round cushions that had to be snapped into their rainproof casings she gave up with a groan and rushed headlong out of her cabin in search of Beryl.

Fortunately Beryl waited table on the second shift and so she found her reading a magazine, with one leg flung over the arm of her chair.

'I can't make my pack,' Harriet said hysterically, bursting into Beryl's cabin without even knocking at the door.

Beryl swung her leg around and got out of her chair, 'I'll make your pack,' she said in a calm voice, knocking some tobacco out of her pipe. 'I would have come round this morning, but you said last night you wanted to make it alone.'

'It's Sadie,' Harriet complained. 'It's that cursed lunch with Sadie. I can't go through with it. I know I can't. I shouldn't have to in the first place. She's not even supposed to be here... I'm an ass...'

'To hell with sisters,' said Beryl. 'Give 'em all a good swift kick in the pants.'

'She's going to stop me from going on my canoe trip... I know she is...' Harriet had adopted the whining tone of a little girl.

'No, she isn't,' said Beryl, speaking with authority.

'Why not?' Harriet asked. She looked at Beryl almost wistfully.

'She better not try anything...' said Beryl. 'Ever hear of jujitsu?' She grunted with satisfaction. 'Come on, we'll go make your pack.' She was so pleased with Harriet's new state of dependency that she was rapidly overcoming her original

shyness. An hour later she had completed the pack, and Harriet was dressed and ready.

'Will you go with me to the souvenir booth?' she begged the waitress. 'I don't want to meet her alone.' She was in a worse state of nerves than ever.

'I'll go with you,' said Beryl, 'but let's stop at my cabin on the way so I can change into my uniform. I'm on duty soon.'

They were nearly twenty minutes late arriving at the booth, and Harriet was therefore rather surprised not to see Sadie standing there. 'Perhaps she's been here and gone back to the lodge for a minute,' she said to Beryl. 'I'll find out.' She walked up to the souvenir counter and questioned the Indian, with whom she was slightly familiar. 'Was there a woman waiting here a while ago, Timothy?' she asked.

'A dark middle-aged woman?'

'That's right.'

'She was here for an hour or more,' he said, 'never budged from this stall until about fifteen minutes ago.'

'She couldn't have been here an hour!' Harriet argued. 'Not my sister... I told her one-thirty and it's not yet two.'

'Then it wasn't your sister. The woman who was here stayed more than an hour, without moving. I noticed her because it was such a queer-looking thing. I noticed her first from my chair at the bridge and then when I came up here she was still standing out by the booth. She must have stood here over an hour.'

'Then it was a different middle-aged woman.'

'That may be,' he agreed, 'but anyway, this one left about fifteen minutes ago. After standing all that time she turned around all of a sudden and bought a whole bunch of souvenirs from me... then just when I was punching my belt for the change she said something I couldn't understand – it sounded like Polish – and then she lit out for the bridge before I could give her a penny. That woman's got impulses,' he added with a broad grin. 'If she's your sister, I'll give you her change, in case

she don't stop here on her way back.... But she sounded to me like a Polak.'

'Beryl,' said Harriet, 'run across the bridge and see if Sadie's behind the waterfall. I'm sure this Polish woman wasn't Sadie, but they might both be back there.... If she's not there, we'll look in the lodge.'

When Beryl returned her face was dead white; she stared at Harriet in silence, and even when Harriet finally grabbed hold of her shoulders and shook her hard, she would not say anything.